IMAGES
of America

WELLESLEY

On the cover: The McLeod block was located in Wellesley Hills Square, built by Lyman Putney in the late 19th century. Shown here are druggist Tom West's store on the western end of the building, William McLeod's grocery in the middle, and Merritt S. Keith's market on the eastern end. The block was remodeled into an Italianate-style building around 1920. (Courtesy of the Wellesley Historical Society.)

IMAGES
of America

WELLESLEY

Jennifer A. Jovin with
the Wellesley Historical Society

ARCADIA
PUBLISHING

Published by Arcadia Publishing
Charleston SC, Chicago IL, Portsmouth NH, San Francisco CA

Printed in the United States of America

Library of Congress Catalog Card Number: 2007939608

For all general information contact Arcadia Publishing at:
Telephone 843-853-2070
Fax 843-853-0044
E-mail sales@arcadiapublishing.com
For customer service and orders:
Toll-Free 1-888-313-2665

Visit us on the Internet at www.arcadiapublishing.com

For my parents, Donna and Dale Jovin,
who always encouraged my ambitions and made me
believe I could do anything I set my mind to.

CONTENTS

Acknowledgments 6

Introduction 7

1. Wellesley, Formerly West Needham 9

2. Faces around Town 19

3. Living in Wellesley 51

4. Wellesley's Dedication to Education 63

5. Social Life 87

6. Local Enterprise 109

ACKNOWLEDGMENTS

Over the past year and a half, I have been fortunate to become familiar with the collections and the people who make up the Wellesley Historical Society. I have uncovered fascinating stories and have met some very knowledgeable and generous people.

I owe a huge debt of gratitude to the Wellesley Historical Society's executive director, Elizabeth Krimmel. She welcomed me into the society as a graduate intern and taught me more than I could have learned in any course. She gave me complete access to the society's collections and has supported this project since the beginning. She has been the kind of mentor that everyone hopes for, is a great friend to work with, and has been an integral part of my professional success.

I would also like to thank the academic librarians who allowed me to utilize their collections, including Pam Kaplan at the Dana Hall School, Wilma Slaight and Ian Graham at the Wellesley College Archives, and R. C. Rybnikar at the Babson College Archives. Additionally, I would like to thank Robert Chellis and Stanley Pratt, who loaned me photographs from their personal collections.

Thank you to Wellesley historians Tory DeFazio and Beth Hinchliffe, who have given advice and shared their expertise about the town they know and love.

I want to recognize all of the teachers who encouraged and enlightened me over the course of my education, including the faculty in the Needham Public Schools, who provided me with the best educational foundation possible; the department of history at the University of Massachusetts–Amherst, particularly professors Gerald McFarland, Robert Jones, Richard Minear, and Bruce Laurie, who made me excited about local history in the first place; and the department of history at Northeastern University, especially professors William Fowler and Harvey Green, who guided me in the direction of public history. All of you helped me get where I am today.

Finally, to my parents, Kate, and Chris, you have kept me sane and given me a boost when necessary. I would not be the person I am today if it were not for your support and love.

Unless otherwise indicated, the photographs in this publication came from the archives of the Wellesley Historical Society.

INTRODUCTION

Wellesley is one of the towns in New England whose settlement long predates its political incorporation. Although Andrew Dewing and a handful of other English settlers arrived in the geographic location that is now Wellesley in the 17th century, the town did not become an independent municipality until 1881. From 1636 to 1881, the settlement was part of Dedham (1636–1711) and Needham (1711–1881). The Needham settlers separated from Dedham at the beginning of the 18th century, motivated in large part by the distance the settlers needed to travel to attend weekly church services. The Dedham meetinghouse was located in what is now Dedham Square, which meant that the residents furthest west had to travel about seven miles each way by foot or by carriage. The Charles River winds through this area and is the physical boundary between the current towns of Needham and Dedham. During inclement weather, the river flooded and made the ground impassable. In 1711, the colonists in the northwestern section of town succeeded in gaining political independence and established the new center of Needham about one mile northwest of the current center of Needham and about three miles from what is now Wellesley Square. Over the next 170 years, the residents of the west precinct developed their own character and identity in their own distinct villages, West Needham and Grantville. After the American Revolution, the West Needhamites worked more diligently to separate themselves from the eastern part of town through the establishment of their own meetinghouse, which became the Wellesley Congregational Church, and repeated petitions to the Massachusetts legislature asking for political independence.

Since its early days as West Needham, Wellesley has been a town with many active citizens. Horatio Hollis Hunnewell financed the first central library and town hall building. Hunnewell is also credited with giving the town its name, which was the name of his estate on Lake Waban. Isaac Sprague V donated some of his land for the building of a new elementary school on Oak Street in addition to serving as the first president of the Wellesley Historical Society. Gamaliel Bradford Jr., Joseph Fiske, Ellen Ware Fiske, Margaret Urann, and Beth Hinchliffe have all contributed to local historiography so future Wellesleyites would have the opportunity to learn about their community's history. Wellesley has boasted famous artists, like Mary Brewster Hazelton, famous writers, like Eleanor Early, as well as ordinary people who proudly served their town, such as town clerks John Ryan and Solomon Flagg. Wellesleyites have contributed to the political and social community through elected office and academia. Those who contributed most to Wellesley's economic, educational, and social development also settled with their families in the town's developing neighborhoods. Property in Wellesley evolved from modest farmhouses in the 17th and 18th centuries to larger estates in the 19th and 20th centuries that boasted appealing landscapes and sophisticated architecture.

Wellesley gained its reputation as an educational mecca in the 19th century when Henry Fowle Durant received the charter for the Wellesley Female Seminary in 1870. West Needham's own public high school opened in the 1860s after elementary schoolhouses opened in West Needham in the early part of the 1800s. At the end of the 19th and beginning of the 20th centuries, private schools at all levels opened to give Wellesleyites and others seeking educational opportunities in Wellesley alternative choices. The Dana Hall School opened in 1881 as a preparatory school for Wellesley College, and the Rock Ridge School opened for boys at the end of the 19th century. In the 20th century, three more postsecondary institutions joined the community: Babson College in 1919; Pine Manor College in 1911, which later relocated to Chestnut Hill; and Massachusetts Bay Community College in 1973.

Wellesley residents have been stimulated outside of the classroom through social clubs and service organizations since the town's incorporation. The Wellesley chapters of the Red Cross, Kiwanis Club, and Rotary Club have volunteered their time and assistance to those humanitarian causes while the Wellesley Hills Woman's Club, the Wellesley Symphony, and the garden clubs have added to the social, intellectual, and aesthetic quality of the community. Social organizations have long been available for residents of all ages, from Boy and Girl Scouts to senior clubs at the Wellesley Community Center. Each year from 1978 to 2004, the community center hosted an annual dinner at which the Wellesley Award was presented to the individual or individuals who contributed most to the community. In addition to service and social clubs, Wellesley also hosts a variety of religious denominations, some of which predate the town's establishment while others were additions of the 20th century. Since the west precinct first established its own congregation in the 18th century, there have been four Congregationalist churches in Wellesley Square. Other congregations have started in temporary quarters before receiving their own space for worship. The Unitarian Society initially met in Maugus Hall before its church was dedicated in 1888, and Temple Beth Elohim shared space at the Universalist church before building its own synagogue in the 1960s.

Before Wellesley became known for its stylish boutiques and suburban department stores, the square housed variety stores, taverns, and small industries. Groceries and general stores also opened in Grantville, now Wellesley Hills, and shaped the development of that section of town. Through the 19th century, the square and the hills resembled many other small New England villages whose landscapes were dotted with churches, store blocks, and railroad and trolley tracks. The Boston and Worcester Railroad and the Natick and Cochituate Railway facilitated easier access between the rural towns and Boston so outside goods could be more easily imported for sale and people could leave Wellesley to go to Natick, Newton, Needham, and Boston to see what those towns and cities had to offer. People from Boston sought refuge from the busy lifestyle and polluted city air in Wellesley's open spaces and hotels. Over time, stores that were once unique to the urban landscape started moving out into the suburbs. Well into the 20th century, independent stores also maintained their place in the commercial part of the community. Seiler's restaurant in Wellesley Square served breakfast, lunch, and dinner at their bakery and diner during the mid-20th century, the Hathaway House Bookshop sold textbooks and fiction to Wellesley College students and townspeople alike, and the Wellesley Community Playhouse showed second-run films in Wellesley Hills until the 1980s.

Although Wellesley's early years may seem inconspicuous, beginning in the mid-19th century and continuing through to the present, the two villages we now know as Wellesley thrived. Wellesley's businesses, churches, social organizations, and schools developed because of the entrepreneurs, educators, and residents who had a vision of the community they wanted. Natural beauty, sophisticated architecture, and high-quality educational facilities were top priorities for the founding fathers and mothers of Wellesley. The photographs in this book show the evolution of these values and will introduce current Wellesley residents to the people who made their town what it is today.

One

WELLESLEY, FORMERLY WEST NEEDHAM

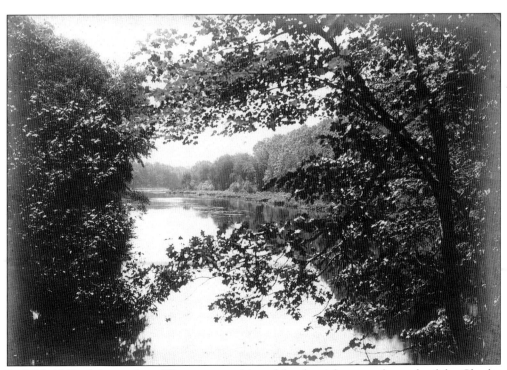

In 1635, 19 Englishmen from Watertown petitioned for the right to settle south of the Charles River and on a five-mile tract north of the river. This land was called Dedham. After 1711, the tract above the Charles River became Needham. The residents of Needham wished to establish their own village because it was difficult to make the weekly trek to the meetinghouse, particularly when the river flooded during the winter.

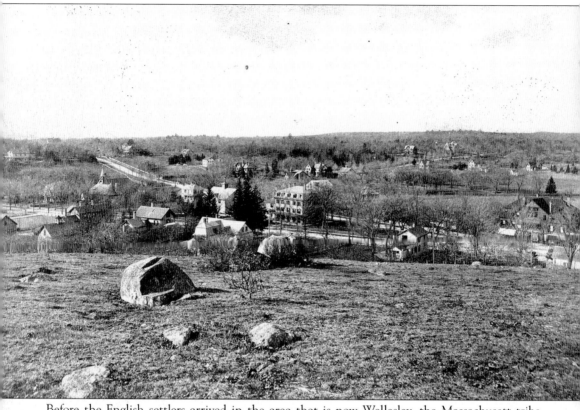

Before the English settlers arrived in the area that is now Wellesley, the Massachusett tribe inhabited the region. According to Joseph Fiske's history of Wellesley, the settlement of Dedham agreed in 1680 to give Chief William Nehoiden £10 40s. worth of Native American corn, and 40 acres of land for a seven-mile-long by five-mile-wide piece of land, which included the current towns of Needham and Wellesley. In addition, Dedham settlers gave the sachem Magos three pounds of Native American corn and £5 currency for the land around Magos's hill, seen here. The Native Americans migrated west from the Blue Hills they had called home to settle in the areas that now comprise part of Wellesley and South Natick along with John Eliot, who is famous for his Algonquin translation of the Bible. Among the first English settlers to the Wellesley area was Andrew Dewing, who is credited with building the first garrison house in Wellesley.

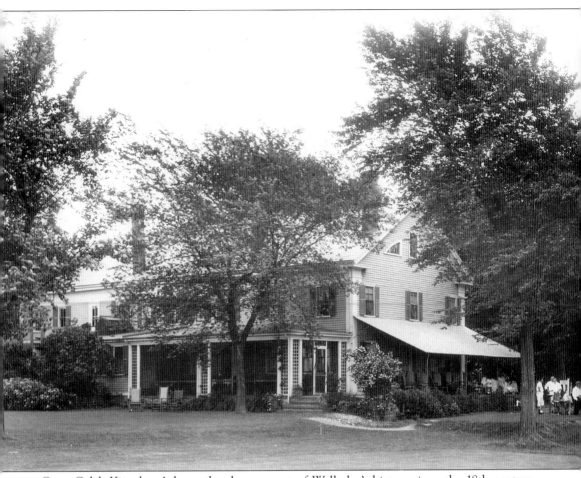

Capt. Caleb Kingsbury's house has been a part of Wellesley's history since the 18th century. West Needham Minutemen left from Kingsbury's on April 19, 1775, to join other colonists fighting in Lexington. In 1828, Needham bought the property and converted it into the town poor farm. West Needhamites met here when the building was the town hall and voted to secede in 1881. Like the American colonists a century before, the men of Wellesley wanted to be able to regulate their own village and not answer to a distant government. Even after Wellesley incorporated, the poor of Needham continued to live there. Joseph Fiske recalled that the representatives from Wellesley made a contract to board Needham's poor people for the year ending on March 31, 1882, for $2 per week. In 1910, the building was leased to the Wellesley Country Club Corporation. In 2006, the club hosted the Wellesley Historical Society's 125th anniversary gala, thus reminding Wellesleyites of the building's historic significance.

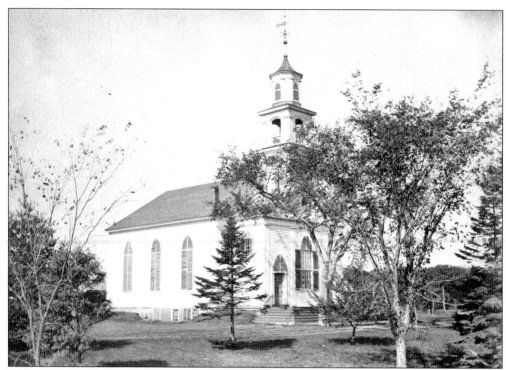

Because West Needhamites believed the Needham meetinghouse to be too far to attend weekly, a west parish was set off by a vote of town meeting on October 3, 1774. The first recorded meeting of the west parish occurred on January 19, 1775. A meetinghouse was erected in 1778, but it was not completed for 20 years because of the Revolutionary War. This second meetinghouse (above) replaced the first in January 1835. A third church (below) was built and dedicated July 11, 1872. This building remained the town's Congregationalist meetinghouse until it was destroyed by fire on December 31, 1916. The fourth church was dedicated October 21, 1923.

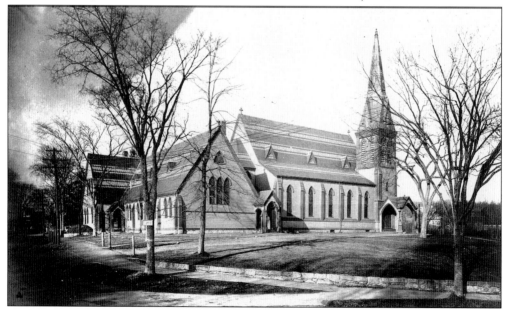

When Wellesley was still a part of Needham, the section of town now known as Wellesley Hills was known as North Needham. In the mid-19th century, North Needham changed its name to Grantville after Moses Grant presented the new Orthodox Congregational Church in that village with a bell. After Wellesley's incorporation, Grantville became Wellesley Hills.

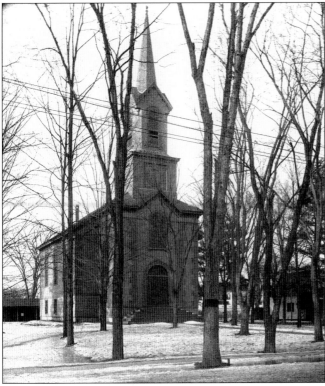

On July 1, 1846, 28 members of the West Needham meetinghouse seceded from that parish in order to follow Rev. Harvey Newcomb and his orthodox Calvinist views. The members formed the Orthodox Congregational Church in North Needham. Now the Wellesley Hills Congregational Church, it is still a vibrant part of the Wellesley Hills Community and it currently hosts Boy Scout troops, a nursery school, and the Wellesley Food Pantry.

In 1810, the Worcester Turnpike opened as a toll road and remained a toll route until the Boston and Worcester Railroad's success caused the toll to be removed in 1840. During the War of 1812, the turnpike was used to transport merchandise to western Massachusetts and to New York. When it was a toll road, the Wellesley tolls were at the junction of the turnpike at Blossom Street, which is now Weston Road. The turnpike became a state highway—now called Route 9—in the 1930s. This photograph shows the intersection of what are now Routes 9 and 16 before the trolley came through Wellesley Hills around 1900. Route 16 served as the main road from Boston to Sherborn after it was laid in 1671. These roadways and later the railways allowed Bostonians to escape the city and take in the healthful air and hospitality Wellesley had to offer. (Photograph by A. W. St. Clair.)

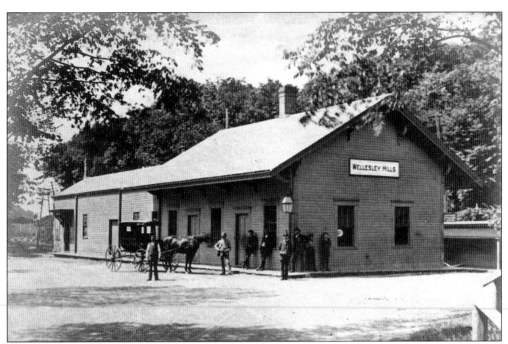

In 1834, West Needham received its own steel highway. The Boston and Worcester Railroad reached West Needham, now Wellesley Square, via Rice's Crossing, which is now the Wellesley Farms station. Initially the railroad was supposed to go through Newton Lower Falls, but topographical obstacles caused the railroad to be rerouted. Before the railroad, the Worcester Turnpike had carried people and materials across Massachusetts and to New York. The Wellesley Hills railroad station (above) was designed by H. H. Richardson, the architect of Trinity church in Boston, and renowned landscape architect Frederick Law Olmsted designed the station grounds. The Wellesley Square station (below) was designed by the successor to Richardson's company.

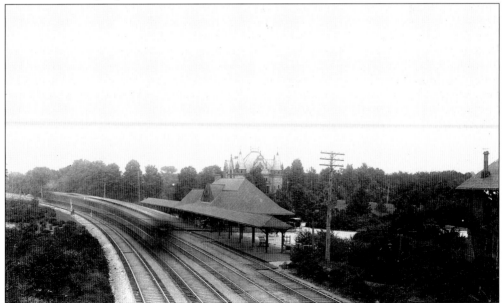

In 1824, toll-keeper Daniel Dadmun built a house at the junction of the Worcester Turnpike and Weston Road. After his death, his daughter Elizabeth inherited the house. Her niece acquired the house in 1911 and sold it to the McNamaras in 1923. The McNamara family gave the house to the Wellesley Historical Society in 1974, and in 1975, the house moved to Wellesley Hills to become the society's headquarters. (Photograph by John T. Ryan.)

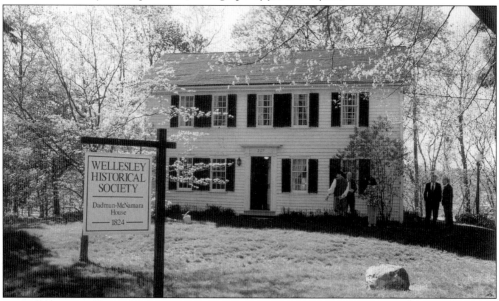

In 1925, historically minded citizens founded the Wellesley Historical Society to make young Wellesleyites and new residents aware of the town's history. Initially the society had space in the town hall; later, the main and the Wellesley Hills branch libraries hosted the society's collections. Margaret Urann served as the first curator, and Isaac Sprague V was the first president. Since its inception, residents with strong ties to the Wellesley community have presided over the historical society. (Photograph by John A. Tucker of the Wellesley Historical Society.)

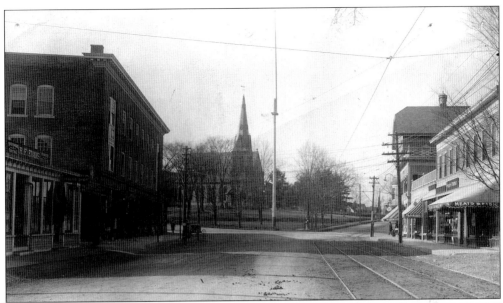

After Wellesley was incorporated in 1881, the town square rapidly grew into a commercial center. The telephone became commonplace in Wellesley during the 1890s thanks to Alexander Graham Bell, who lived in Wellesley Lower Falls in 1871. The Natick and Cochituate Street Railway rolled into town in 1896, bringing Wellesleyites to Boston every half hour. The trolley helped unify the square and Wellesley Hills, which had effectively been two villages while part of Needham. (Photograph by John T. Ryan.)

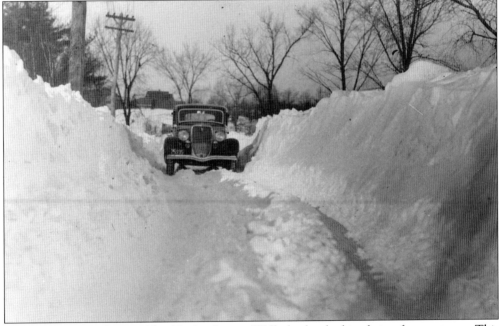

As is to be expected in any New England town, Wellesley has had its share of snow storms. This photograph depicts a storm in 1945. In 1960, the town had a storm that the *Wellesley Townsman* called the "worst storm in many years." During that storm, many businesses remained closed and those that opened were not fully staffed.

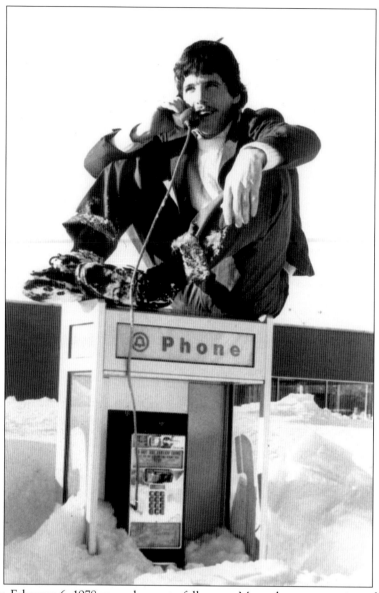

On Monday, February 6, 1978, snow began to fall across Massachusetts, creating what became known as the blizzard of 1978. Twenty-seven inches fell in Boston between the sixth and the seventh, leaving life in the Northeast at a standstill. In the Wellesley area, people were stuck in their cars along Route 128, Route 9, and Washington Street. Blocked roadways prevented delivery trucks from servicing the town, and Wellesleyites faced the possibility of food, oil, and gas shortages. Getting around was difficult for police officers trying to give assistance. One baby was born en route to Newton-Wellesley Hospital. Fortunately there were not any significant power outages in Wellesley and most of the townspeople accepted the snow storm as an impromptu vacation. Residents on Lilac Circle held a cookout and people all over town became better acquainted with their neighbors and rekindled friendships. Eleanor Mullin and the Friendly Aid ensured that the elderly were taken care of and received their meals in spite of the snow. It took about a month for the snow to be cleaned up, but in the meantime, Wellesleyites made the best of a snowy situation.

Two

FACES AROUND TOWN

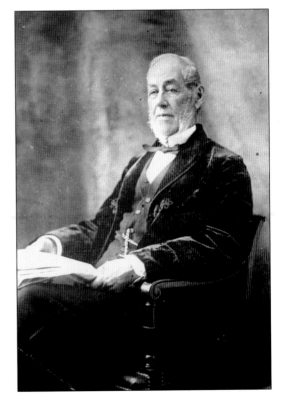

Horatio Hollis Hunnewell (1810–1902) was Wellesley's benefactor. He built Wellesley's first library in 1883 and a new town hall in another section of the same building in 1885. Hunnewell also donated land on Washington Street that became Hunnewell Field. Hunnewell's descendants continue to live in Wellesley. Seven of the eight homes H. H. Hunnewell built for his children are occupied by family members and the eighth belongs to Wellesley College.

Called "the father of American biography," Gamaliel Bradford Jr. (1863–1932) came with his father, Gamaliel Bradford Sr., to Wellesley as a child after being born in Boston. He was an eighth-generation descendant of Gov. William Bradford of the Massachusetts Bay Colony. Gamaliel Sr. was a banker and political writer, but his son was moved by the written word and became a poet and writer. He wrote "psychographs," which he characterized as works that focus on "what concern[s] the man's soul [and] excludes all considerations of achievement in itself." He also dabbled in historical writing, authoring *Early Days in Wellesley*. Gamaliel Jr. married Helen Ford in 1886, who was later a charter member of the Wellesley Hills Woman's Club.

Known for his role as an agitator in the movement to break away from Needham, Joseph E. Fiske (1839–1909) was an active member of the Wellesley community in the late 19th century. After graduating from Harvard College in 1861, Fiske enlisted in Company C of the 43rd Massachusetts Volunteers in 1862. After the Civil War, Fiske enrolled in the Andover-Newton Theological School and graduated in 1867. He was elected a selectman of Needham in 1873, a member of the Massachusetts House of Representatives from 1873 to 1874, and served on the school committee from 1876 to 1879. He became the chairman of the first school board of Wellesley and served until 1894. Fiske was the first president of the Maugus Club and a charter member of the Wellesley Club, serving as its first president from 1898 to 1901.

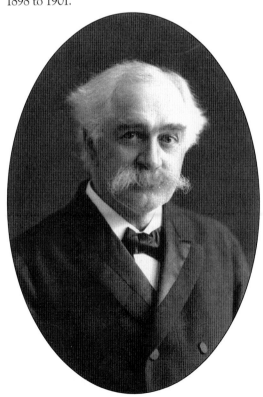

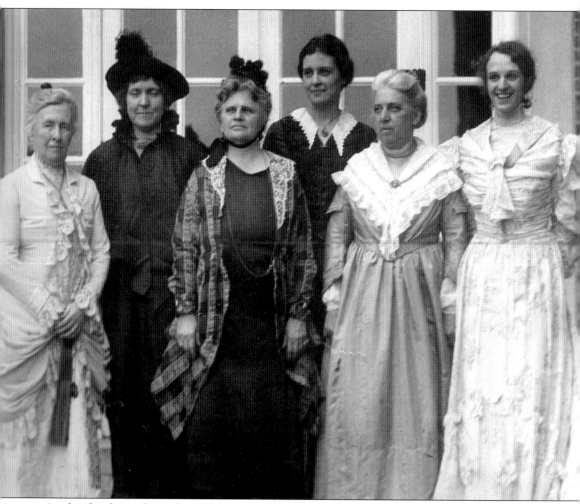

As the daughter of Joseph E. Fiske, Ellen Ware Fiske was charged with editing his notes on Wellesley's history, which was published as *The History of the Town of Wellesley, Massachusetts* in 1917. Until her father and stepmother died, Ellen was a devoted daughter and cared for them during their respective illnesses. An 1892 graduate of Wellesley College, she was the secretary of the Wellesley Historical Society, and she promoted the town's history through lessons to fourth graders and through town celebrations. She was also socially active: she served as the secretary to the board of directors of the American Red Cross's Wellesley chapter, and she held the position of honorary life member of the Wellesley Hills Woman's Club. She was the secretary to the committee that planned the 1931 Wellesley semi-centennial, which is depicted here. She is the third person from the left.

Esther Oldham's (1900–1984) childhood interest in fans led her to become one of the foremost fan collectors in the world. She accumulated over 1,000 fans, 500 of which are at Boston's Museum of Fine Arts. The oldest fan in the collection dates to 1590. Oldham shared her expertise in lectures throughout the United States and published articles here and in Europe. She began her lace collection, which is housed at the Wellesley Historical Society, during the last 20 years of her life. Oldham was the daughter of Arthur Oldham, who started the football rivalry between Wellesley and Needham high schools. This lace sample was a gift to the historical society from Anne Borntraeger, niece of Esther Oldham.

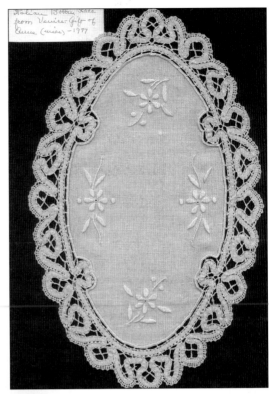

George Ware (1833–1916) was descended from some of the earliest settlers in Wellesley. His ancestor Robert Ware received a land grant from Dedham in 1642. George was born in the family's home on Wellesley Hills Square in 1833. His father, Dexter Ware, was one of the founders of the Wellesley Hills Congregational Church. Those who knew George described him as a kind person who was dedicated to serving others.

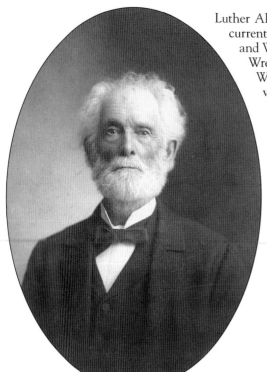

Luther Allen Kingsbury was born in 1818 on what is currently Washington Street. He attended Holliston and Wrentham Academies and then taught at the Wrentham Academy and the North School in Wellesley. In his adult life, Kingsbury kept a village store and served as a member of the Needham School Committee. Kingsbury was the namesake for the school on Park Avenue and Seaver Street that has since been converted into a condominium complex.

Seldon L. Brown came to Wellesley in 1886 to fill the role of the high school principal, a position he held for 30 years. After his tenure in Wellesley, where he became known as "Pa" Brown, he went on to teach at the Huntington School in Boston for 13 years after World War I. Brown later returned to Wellesley and became involved with the Beacon School for Boys in Wellesley Hills.

Henry Fowle Durant was born Henry Welles Smith in Hanover, New Hampshire, in 1822. He was educated at Mr. and Mrs. Samuel Ripley's private school in Waltham to prepare for Harvard Law School. After he passed the bar, Henry changed his name because there were already three Henry Smiths practicing law in Boston. Fowle and Durant were family names. Durant married Pauline Adeline Fowle in 1854 and they lived in Boston. The tragic death of their son Harry in 1863 led Durant to give up law and move to his country home in West Needham. There he decided that he would provide education for women. Pauline, never having attended college, enthusiastically supported her husband, and together they laid the cornerstone of the Wellesley Female Seminary, later Wellesley College, in 1871. (Courtesy of the Wellesley College Archives.)

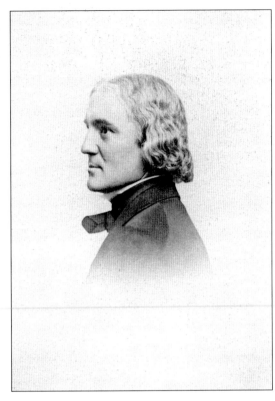

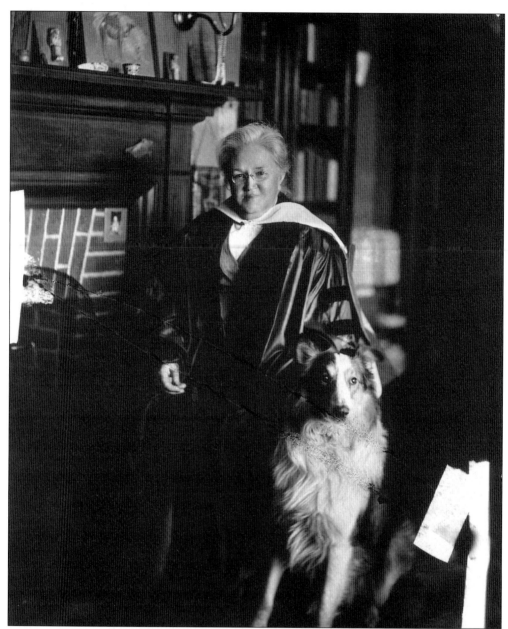

Katharine Lee Bates (1859–1929) was born in Falmouth, moved to Wellesley in 1871, and graduated from West Needham's high school. Bates graduated from Wellesley College in 1880, taught at Dana Hall School and Natick High School, and became a professor at Wellesley College. She was the head of the Wellesley College English department from 1891 until 1920. While on a trip to Colorado, she ascended Pike's Peak and was inspired to write "America the Beautiful." The college and Wellesley Congregational church choirs were the first in Wellesley to perform Henry Ward Sleeper's musical interpretation of the poem.

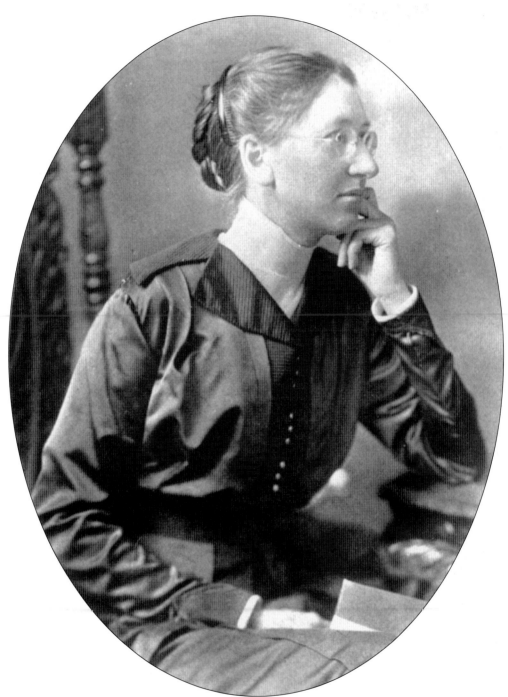

As a member of the Wellesley College faculty, Emily Green Balch (1867–1961) was one of the first people to teach social work classes in the world. She was a professor of economics and sociology starting in 1913. Devoted to world peace, Balch cofounded the Women's International League for Peace and Freedom with Jane Addams. Her opposition to World War I led to her dismissal from the college faculty in 1919. Balch later received the Nobel Peace Prize in 1946. (Courtesy of the Wellesley College Archives.)

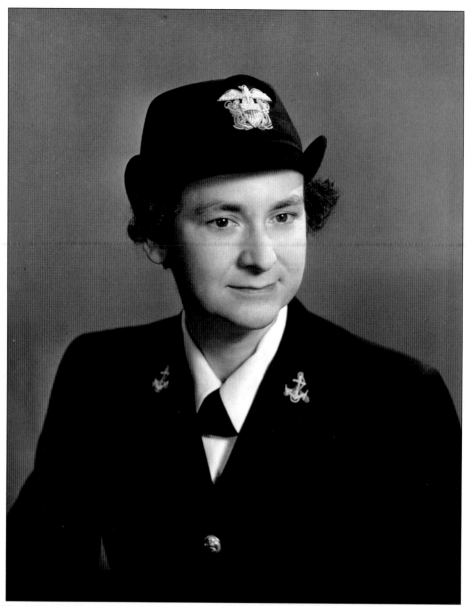

Mildred McAfee Horton was the seventh president of Wellesley College and one of the youngest when she was inaugurated at age 36 in 1936. In 1942, she took a leave of absence to organize the Women Accepted for Voluntary Emergency Service (WAVES) in the U.S. Navy. She was appointed the WAVES director with a rank of lieutenant commander and was promoted to captain in 1943. She was the first woman to receive a commission in the U.S. Naval Reserves. She received the Distinguished Service Medal in 1945 and returned to Wellesley after the war was over. She married Rev. Douglas Horton, who became the dean of Harvard Divinity School in 1955. She retired from Wellesley College in 1949 after 13 years as its president. She distinguished herself outside academia and the military as one of the first women to serve as president of the American Association of Colleges and as a board member of the National Broadcasting Company, the Radio Corporation of America, and the New York Life Insurance Company. She died in 1994 at the age of 94. (Courtesy of the Wellesley College Archives.)

When Henry Durant decided to open a preparatory school for Wellesley College, he called upon Julia and Sarah Eastman to be the first headmistresses of the Dana Hall School. Sarah (right) had been an instructor in the history and English literature department from 1875 to 1881 and Julia (below) served as an assistant in English in 1880. Sarah attended Mount Holyoke Female Seminary and graduated in 1861. Julia was educated at academies in Amherst, Ipswich, and Monson. Both women taught at other schools before coming to Wellesley. Julia also authored children's books in the 1860s and 1870s. The Eastmans administered Dana Hall until 1899, after which point they retired to Denton Road. Sarah died in 1911, and Julia died in 1930. (Courtesy of the Dana Hall School Archives.)

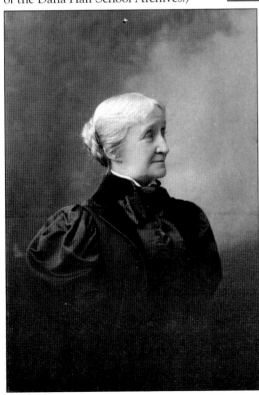

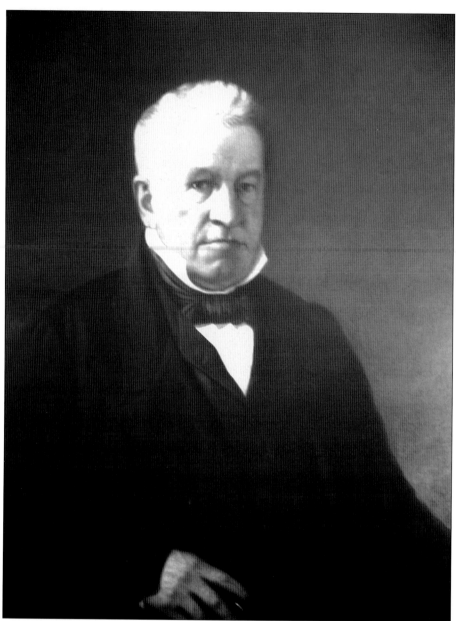

Initially a summer resident of Wellesley, Charles Blanchard Dana moved into town permanently after his retirement. Dana had made his fortune in the East India trade, having moved to Boston as an adult after growing up in Maine. From the 1860s on, Dana acquired land between Spring and Benvenue Streets and from Grove to Brook Street. When the third Congregational church was built, Dana purchased the second one for $1,000 and removed it to his property on Grove Street, where it was a boardinghouse before he gave it to Henry Durant and Wellesley College. The building housed older students coming to Wellesley to continue their education. In 1881, this building became the Dana Hall School. Dana died in 1896 and his son Arthur inherited what remained of his property. The younger Dana sold more of the family property to Helen Temple Cooke for the expansion of the Dana Hall campus. (Courtesy of the Dana Hall School Archives.)

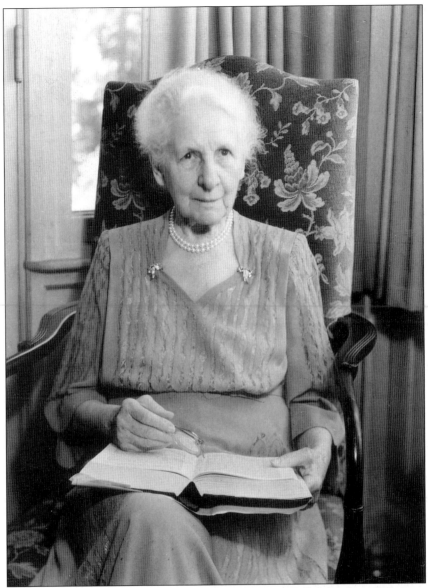

Helen Temple Cooke became the headmistress of the Dana Hall School in 1899, immediately succeeding the Eastman sisters. She had started her career in education at age 17 when she helped run a small private school near her home in Rutland, Vermont. Cooke initially came to Wellesley to bring one of her Rutland pupils to Dana Hall. Because of her experience in Vermont, Cooke was hired to teach and, ultimately, run the school. During her tenure at Dana Hall, she expanded the campus from two-and-a-half acres to almost 100 acres. When expanding the living facilities, Cooke chose to add cottages rather than dormitories to the landscape to create a homier atmosphere for the girls. She broadened the school's mission to teach a general curriculum instead of only college preparatory courses. Cooke believed that "the task of the school [was] to help each girl to think." Cooke retired from her role as headmistress in 1951 but she remained the president of the board of trustees until her death in 1955. This photograph was given to the Wellesley Historical Society by the office of public relations at Pine Manor Junior College in 1967.

After graduating from the Massachusetts Institute of Technology in 1898, Roger Ward Babson moved to Wellesley in 1900, where he founded a statistical business that distributed information to bankers, manufacturers, and merchants worldwide. He then founded the Babson Institute of Business Administration in 1919 on his Abbott Road property. In 1927, Babson founded Webber College in Babson Park, Florida, to train young women interested in business, financial, and secretarial careers. Babson believed in a practical education that combined both class work and real-world experience. He did not include the liberal arts in his school's curriculum because he thought students could learn those subjects elsewhere. Although he concentrated on business professionally, Babson had a variety of interests. A deeply religious man, he campaigned for moral behavior, going so far as to run as the National Prohibition Party candidate for the president of the United States in 1940. (Courtesy of the Babson College Archives.)

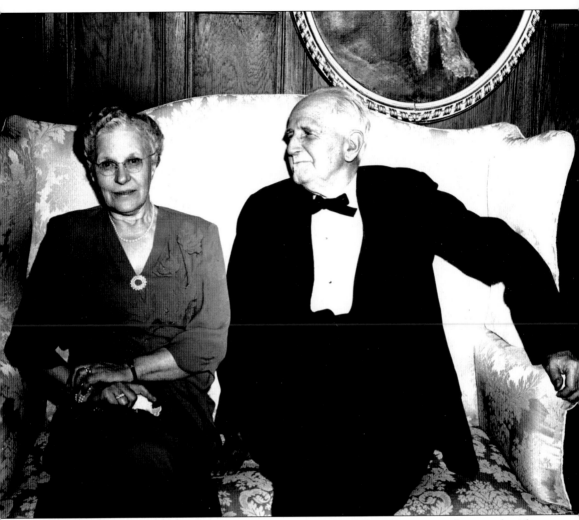

Babson married Grace Margaret Knight in March 1900. When Roger was diagnosed with tuberculosis in 1901, Grace used her training as a nurse to care for him. Together they had one daughter, Edith Low Babson, who was born in December 1903. Over the years, Grace worked to acquire items related to Isaac Newton. Roger had become enamored with Newton's philosophies while a student at the Massachusetts Institute of Technology. Grace began collecting items of "Newtonia," including the shell of the parlor from Newton's home in England. When Newton's home was going to be torn down in 1913, Philips and Company of Hitchin salvaged the pertinent pieces. Grace went to England, saw the room, and had it shipped piece by piece to Wellesley to be added to the library the Babsons were designing. The Babsons' library is now Tomasso Hall, and the Newton Room moved to the new Horn Library in 1980. The Grace K. Babson Collection of the Works of Sir Isaac Newton is on loan to the Huntington Library in California. It is the third-largest collection of Newtonia in the world. (Courtesy of the Babson College Archives.)

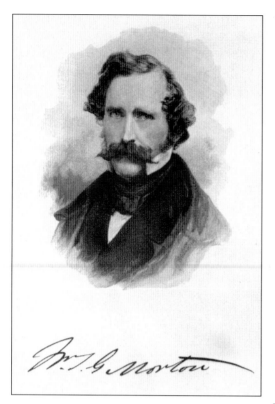

Dr. William T. G. Morton was a dentist who moved to West Needham in 1845. Morton's house occupied part of the lot where the town hall currently stands. Morton experimented with ether as a possible anesthesia and pain reliever. He was the first person to administer ether to a patient undergoing surgery at Massachusetts General Hospital on October 16, 1846.

John Hastings was born in Grantville (Wellesley Hills) in 1846. His father, Aaron Hastings, built the family home at the time of his marriage in 1833. The younger Hastings served in the Union army during the Civil War and pursued a career as a mechanic. He married and had five children. At his death in 1930, John was cutting wood and filling ice saws as his occupation.

Solomon Flagg was the town clerk of Needham from 1850 to 1881 and the Wellesley town clerk from 1881 to 1888. Outside of municipal duty, Flagg led the Wellesley Congregational Church choir for many years. Gamaliel Bradford described Flagg as a "tall, gaunt, solemn, dignified individual, capable also of being gracious and kindly." Flagg built the Eben Flagg house on Central Street as well as a house at the corner of Washington and Church Streets where he kept a tavern.

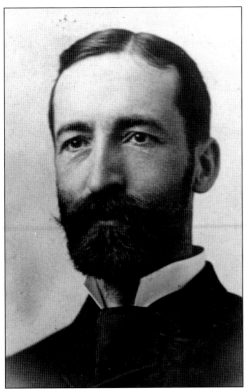

Joseph W. Peabody had humble beginnings and later found professional success. He was born at the town poor farm in 1853 after his father, Ezekiel, married Eliza Kingsbury of Forest Street. As an adult, Joseph had a real estate and mortgage business with an office on Tremont Street in Boston. Later he was involved with Fletcher Abbott and the development of Belvedere Estates and Abbott Road in Wellesley Hills.

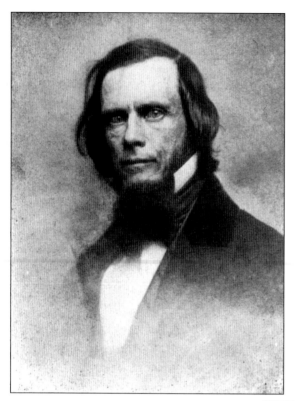

Isaac Sprague (1811–1895), the botanical illustrator who sketched North American birds for J. J. Audubon, lived in Wellesley the last 30 years of his life. According to Gamaliel Bradford, Sprague was also a gifted naturalist. His son Isaac Sprague V was the first president of the Wellesley National Bank and the first president of the Wellesley Historical Society.

Marvin Sprague was the brother of Isaac Sprague V. Like his brother, Marvin was involved in the business community. He was the first trust officer of the Boston Safe Deposit and Trust Company from 1909 to 1920. Marvin was also the auditor of the town of Wellesley from 1902 to 1908 and the first treasurer of the Wellesley Country Club.

Martha Jane Morse Lovewell was the wife of Charles Baker Lovewell and a member of the family after which Morse's Pond was named. The Morse family settled in Wellesley in 1659 after being among the founders of Dedham. Martha's parents were Daniel and Mehitabel Morse of Central Street in West Needham, who were among the original members of the Wellesley Congregational Church.

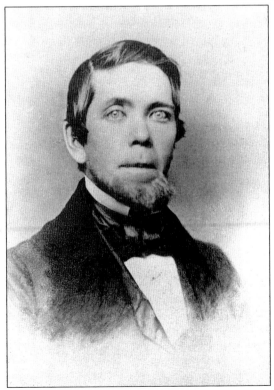

Charles was a shoe manufacturer in Wellesley Square prior to the town's incorporation. To house his employees, he built cottages along the stretch of road near his factory. In 1876, this road was renamed Cottage Street. The factory later became the Eliot dormitory at Wellesley College. His son S. Harrison Lovewell worked at his father's shoe shop before pursuing a career in music.

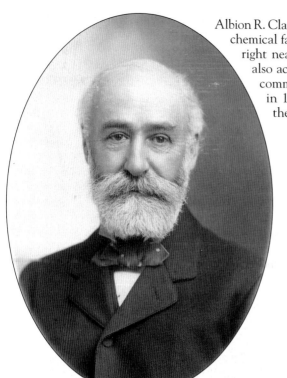

Albion R. Clapp was a partner in the Billings and Clapp chemical factory in the Lower Falls section of town, right near the Wellesley-Newton border. He was also active in civic affairs. Clapp served on the committee that instigated Wellesley's secession in 1881, and he was involved in developing the new town's public utilities.

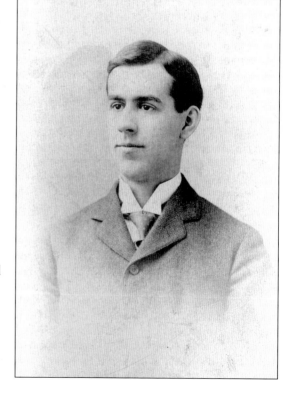

An active member of the Wellesley community, Albion Billings Clapp (c. 1874–1961), son of Albion, was only seven years old when the town was incorporated. He graduated from Harvard College in 1896 and worked for the National Bank of Redemption in Boston and then for N. W. Harris and Company until 1903. Socially he was a charter member of the Maugus Club, a member of the Kiwanis Club, and a town meeting member.

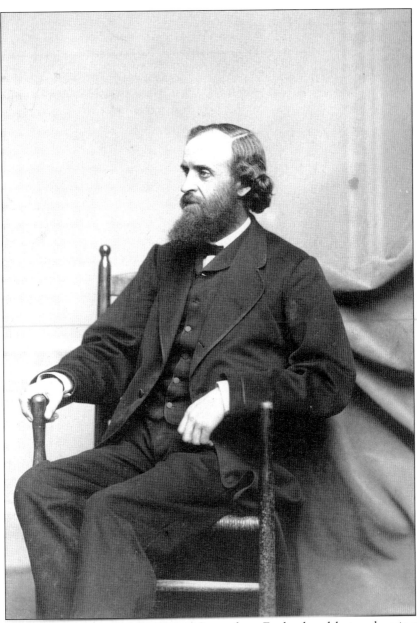

William Denton immigrated to the United States from England and lectured against slavery and about other topics, including evolution, temperance, geology, and free thought. Originally a preacher, Denton left England because he disapproved of too much ecclesiastical authority. He became a proponent of the scientific Enlightenment and a champion of the theory of evolution. Among his professional affiliations was a membership to the Boston Society of Natural History, which preceded the Museum of Science. He regularly toured on the Lyceum circuit in the 1870s with the assistance of his wife, Elizabeth, who handled the travel and lecture arrangements, readied his writings for publication, and attended to his correspondence. The Dentons moved to Wellesley in 1864 where they raised their five children, Sherman, Shelley, William Dixon, Robert Winsford, and Carrie. He continued to lecture worldwide and traveled with his older sons until he died while exploring New Guinea in August 1883.

During their travels with their father, William Dixon Denton (pictured) and Robert Winsford Denton collected butterflies and mounted them using a method their brother Sherman developed. The Denton brothers' collection became world famous. In 1900, it appeared at the international exposition in Paris. They also toured the eastern United States with their butterflies. The brothers made butterfly jewelry from their specimens until William's death in 1923. The Wellesley Historical Society currently houses approximately 1,500 of their butterflies.

Like other members of his family, Shelley Denton was a curious naturalist. He collected insects, bird skins, bird eggs, and mineral and gem stones. Shelley also had a habit of collecting postage stamps, coins, and "Indian relics." In 1910, he opened and operated a gem store on Bromfield Street in Boston.

Born in Boston in 1838, Dr. Isaac Hazelton graduated from Harvard College and served as the assistant surgeon of the U.S. Navy during the Civil War. He was the assistant physician of the New Hampshire State Asylum for the Insane and was at the cutting edge of mental health treatment. After marrying Mary Allen Brewster in 1867, they raised four children in Wellesley Hills, including renowned artist Mary Brewster Hazelton.

After growing up in Wellesley, Isaac Brewster Hazelton pursued studies in civil engineering and architecture at the Massachusetts Institute of Technology. He later switched fields and became an illustrator and portrait painter in New York. Among his more famous works are illustrations in a series of textbooks on American democracy and the Eskimo boy that became the trademark for Clicquot Club ginger ale.

According to John Singer Sargent, Wellesley resident Mary Brewster Hazelton (1868–1953) was one of the foremost portrait painters of her time. She attended the School of Art connected with the Museum of Fine Arts in Boston after her graduation from Wellesley High School. Hazelton maintained a studio in Boston for many years, first in the old Harcourt building and then in the Fenway Studio building. She was the first recipient of the Paige Traveling Fellowship, which allowed her to spend two years in Paris studying with impressionist painters. In 1896, she was the first woman to receive the National Academy of Design's Hallgarten Prize for her painting, "In a Studio." Locally, Hazelton served as a charter member of the Wellesley Society of Artists. She was commissioned to paint the mural at the altar of the Wellesley Hills Congregational Church, which has since been moved to the rear of the church, and designed the widely recognized Liberty Loan campaign poster during World War I.

Eleanor Mary Early (1895–1969) was the oldest child of James Andrew and Sarah Dolan Early of Wellesley. She maintained faithful correspondence with her brother Jack while he was in France during World War I. She never married and had a successful career, first as a journalist, and later, as a novelist. Among her works are the travel book, *And This is Boston!*, and the *New England Cookbook*. Her writing reveals a quick wit and intelligence.

John Joseph "Jack" Early (1896–1921) fought in World War I, became one of the founders of the American Legion, and was the youngest Wellesley selectman when he was elected at age 23. Jack died in 1921 of a heart attack, possibly related to the gassing he suffered while fighting overseas.

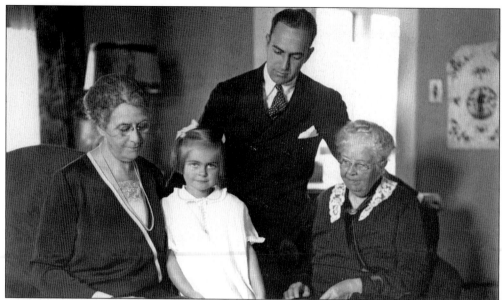

Pictured here are four generations of Pratt family members. On the far left is Ina Angus Pratt, wife of Waldo E. Pratt Sr., who purchased 51 Abbott Road in 1904; Nancy Pratt, Ina and Waldo's granddaughter; W. Elliott Pratt Jr., Ina and Waldo's son; and Eliza Lees Angus, Ina's mother. This photograph was taken on Christmas in 1930. Before Waldo and Ina moved to Wellesley, they lived in the Prattville section of Chelsea in the area where a Pratt ancestor had settled in the 17th century. (Courtesy of Stanley Pratt.)

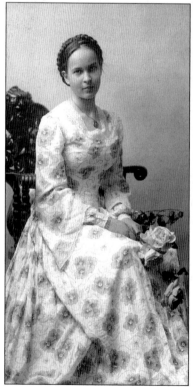

Miriam Pratt was the daughter of Waldo. Miriam married Byron Strahan and they lived at 126 Abbott Road, down the street from her father's home. The Strahans had three children. Their son Waldo lived with his wife, Ann, in Wellesley during the 1950s. After Byron died, Miriam was remarried to John T. Geiger, who was the principal and a teacher at the Phillips School in the second decade of the 20th century. They had four children after they moved to Portland, Maine.

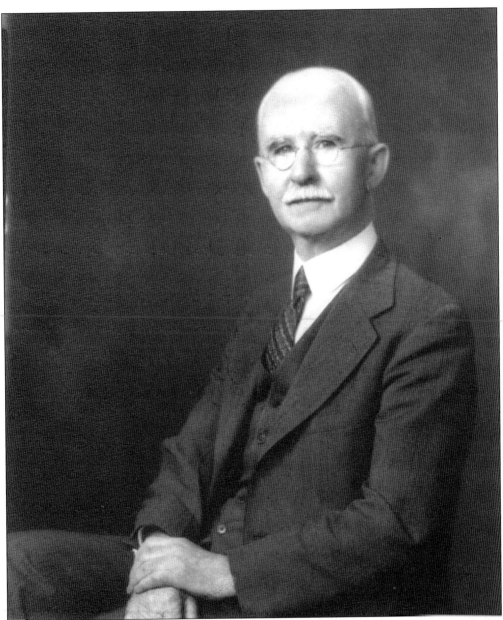

An 1896 graduate of the Boston University School of Law, John T. Ryan came to live in Wellesley in 1900 where he had his own law office. He became the clerk to the board of selectmen in April 1907 after a brief stint as the first editor of the *Wellesley Townsman*, the local newspaper. He served as an agent for public welfare and soldiers' relief, and he took part in organizing the Wellesley Cooperative Bank. He was elected town clerk in 1916, immediately succeeding Frederick H. Kingsbury, who had served from 1888 to 1916. At first, Ryan handled all of the office details alone, but as the population in Wellesley grew, particularly after World War I, he took on an assistant. Ryan remained the town clerk for over 45 years, and even after his retirement, he continued to provide assistance in the office.

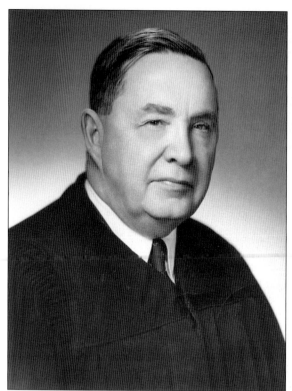

Judge Edmund R. Dewing moved to Grove Street in 1923 and lived there for many years. A graduate of Boston University and a navy veteran of World War I, Dewing was appointed assistant district attorney in 1927, district attorney in 1933, and was elevated to judge in 1954. At the time of his death in 1981, Dewing lived in Plymouth. The *Wellesley Townsman* gave this photograph to the Wellesley Historical Society. (Photograph by J. E. Purdy Company.)

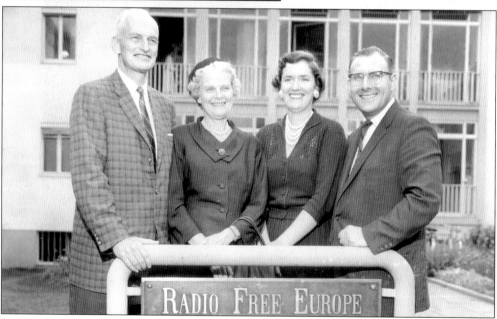

Free Europe Incorporated was founded in 1949 to broadcast news to Eastern European countries under Soviet control. Shown here is Wellesley Hills resident Robert R. Thurber (left) with Rev. James Kirk of Kentucky and their respective wives outside Radio Free Europe's headquarters in Munich, Germany. Thurber and Kirk were winners in Radio Free Europe's 1960 Truth Message program and were taking a prize-winning tour of the Radio Free Europe's European facilities.

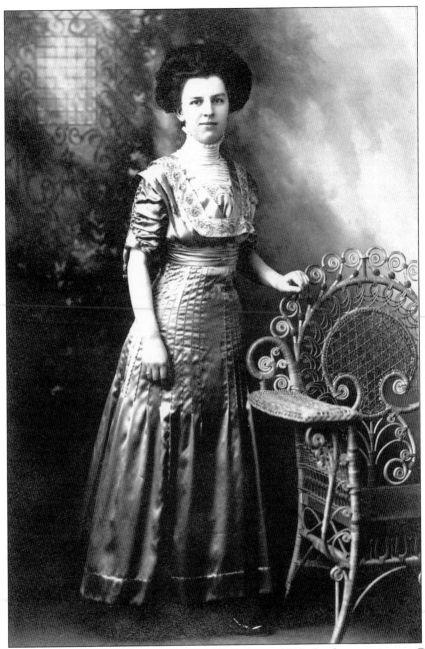

Isabelle Holman moved to Middlesex Street in Wellesley in 1916 after her marriage to Clarence Holman and lived there until the family moved to Grove Street in 1937. Isabelle was an active member of the Village Congregational Church and a longtime member of the Wellesley Hills Woman's Club. The Holman family owned the block where E. A. Davis and Company was established on Washington Street. Clarence had become the proprietor of E. A. Davis and Company after graduating from Harvard College. His aunt Emma A. Davis had started the company as a dry goods store in 1905. The store had been one of the first businesses in what was then the Partridge block on Central Street in Wellesley Square. Holman block was erected at the corner of Washington and Church Streets in 1920.

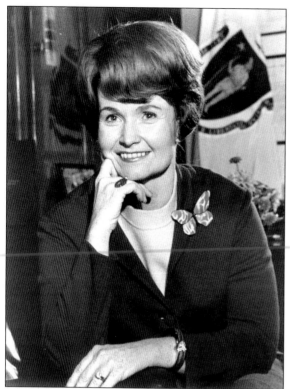

Margaret Heckler wore many hats over the course of her political career, including that of congresswoman, ambassador, and cabinet member. Trained as a lawyer at Boston College, Heckler, then a Wellesley resident, began her political career as a governor's councilor for the Commonwealth of Massachusetts from 1962 to 1966. From January 3, 1967, to January 3, 1983, Heckler served in the U.S. Congress as a Republican representative from the Tenth Congressional district. In 1983, Pres. Ronald Reagan appointed Heckler as the secretary of health and human services. She was the ninth woman to serve in a president's cabinet. From 1985 to 1989, she served as the U.S. Ambassador to Ireland. Heckler currently resides in Arlington, Virginia. (Below, photograph by Robert W. Chalue.)

No author can write a history of Wellesley without discussing Margaret Urann's (1902–1993) contributions. Urann moved to Wellesley in 1914 and received a bachelor of science degree in social work from Boston University in 1927. In 1929, she joined the staff of the *Wellesley Townsman* as a proofreader; she later became a reporter and society editor. Urann joined the Wellesley Historical Society in 1953. She had already begun her historical work as a writer for the *Wellesley Townsman* and was devoted to keeping the memory of poet Katharine Lee Bates alive. The historical file she started while she worked for the *Wellesley Townsman* was later integrated into the historical society's archives. A corresponding secretary and board member of the Wellesley Historical Society, Urann's presence was sorely missed in the history community after her death in 1993. Pictured below is Wellesley Historical Society president Edward Kingsbury presenting the lifetime service award Paul Revere bowl to Margaret Urann on April 16, 1983.

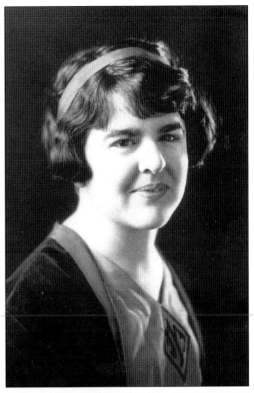

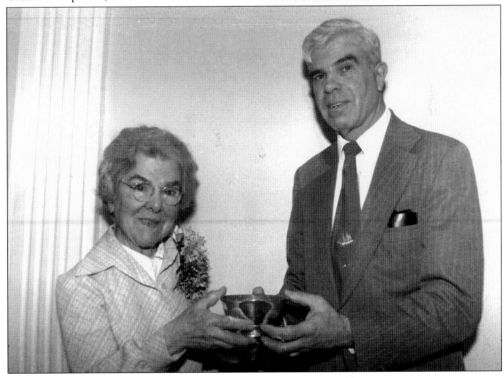

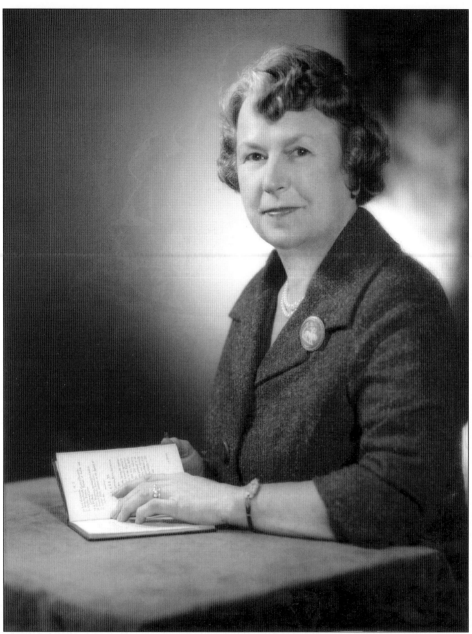

Elizabeth Chellis (1903–2007) assembled the largest library in the world relating to the life and ceramics of Josiah Wedgwood in her home on Windemere Lane in Wellesley. In addition to collecting 18th-century and Wedgwood ceramics, Chellis was a scholar of Robert and Elizabeth Barrett Browning and the librarian and first female president of the Boston Browning Society. She was a founder of the Wedgwood International Seminar in 1956 and was later its president. Chellis was also a member of the Royal Society of Arts, the Wedgwood societies of London, Australia, New York, California, and Washington, D.C., and ceramic societies in England, the United States, and Switzerland. Locally, Chellis was active with two chapters of the Daughters of the American Revolution, the Wellesley Historical Society, and the Wellesley Hills Congregational Church. (Photograph by Bradford Bachrach.)

Three

LIVING IN WELLESLEY

The original part of this 1695 house at 126 Brook Street belonged to Christopher Smith, who was a signer of the 1710 petition to separate Needham from Dedham. Samuel Daggett lived here in 1770 when he was on the committee to separate the east and west precincts of Needham. Reuel Ware, one of the founders of the First Congregational Church in Wellesley Hills, lived in the house and died there in 1882.

The house known as the Seth Dewing House at 106 Benvenue Street was built by Henry Dewing, a grandson of Andrew Dewing who settled in what is now Wellesley in 1644. The house was enlarged over the years by succeeding generations of Dewings. According to the Wellesley Garden Club, the rear section of the house was likely the original house and the Federal-style front was added later.

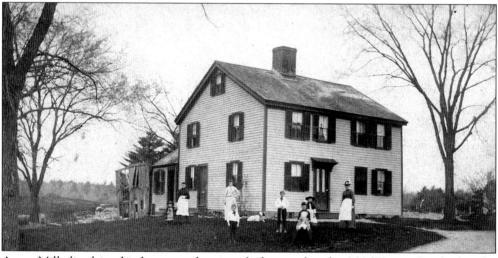

Amos Mills lived in this house at the site of what used to be 264 Weston Road when he fought the British Regulars in Lexington and Concord. He was the only man from town to be killed in that battle. He is the namesake for the Wellesley chapter of the Daughters of the American Revolution.

This 1790 house at 303 Worcester Street belonged to Ephraim Ware, a direct descendant of Robert Ware who came to New England around 1642 and settled in Dedham. Ephraim's widow, Persis Smith Ware, willed the house to the Needham Parish in 1832. Nathan Longfellow later owned this house when he operated a mill on the pond opposite the property that was later called Longfellow Pond.

Jonathan Fuller Sr. and his wife, Polly, moved into this house that was at 122 Great Plain Avenue in 1830 after their son Jonathan Jr. married and moved into their house at the corner of Great Plain and Brook Street. Jonathan Sr.'s son Augustus inherited the house in 1853. Augustus owned the second village store, Waban Hall, with brothers Jonathan Jr. and Edward Granville in Wellesley Square.

This house at 493 Worcester Street was the home of Gamaliel Bradford, Wellesley's famous biographer. According to his *Early Days in Wellesley*, Bradford's father, a banker and political writer, bought this house as a summer home in April 1867. Earlier records of the house indicate that in 1843, Thomas Arnold purchased six acres of land at this site from John Batchelder

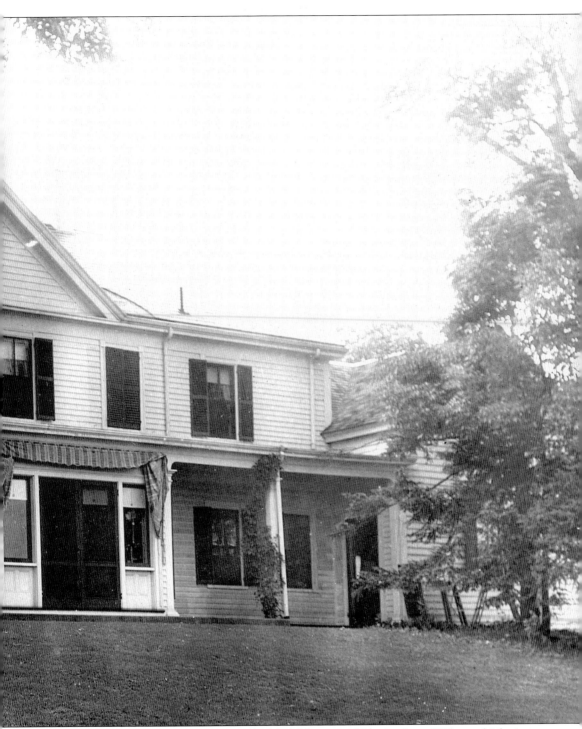

for $180. The house dates to 1848. Bradford lived here until his death in 1932, at which time the house passed to his wife, Helen. (Courtesy of the Wellesley Historical Commission files, Wellesley Historical Society.)

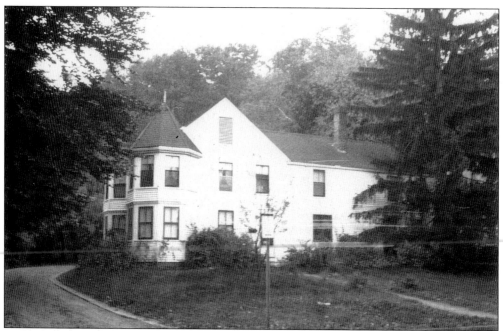

Daniel Morse's (1812–c. 1870) home was located at 32 Weston Road. It is probably the oldest house on the portion of Weston Road between Routes 16 and 135. There was a shoe shop behind the house at one time. After Morse's death, his wife opened the Wellesley Laundry on the property.

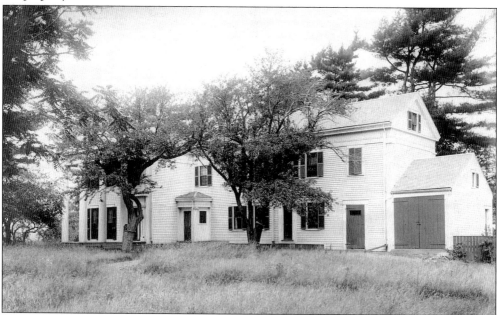

John Smith Bird built this Greek revival home on the northeast corner of Worcester and Oakland Streets in 1848 with the help of carpenter E. P. Chapin. Bird had no children; upon his death, the house belonged to his wife, Sara K. Bird, who then bequeathed the house to her nieces Charlotte A. K. Bancroft and Sarah Bird Bancroft. They lived in the house from 1878 to 1908.

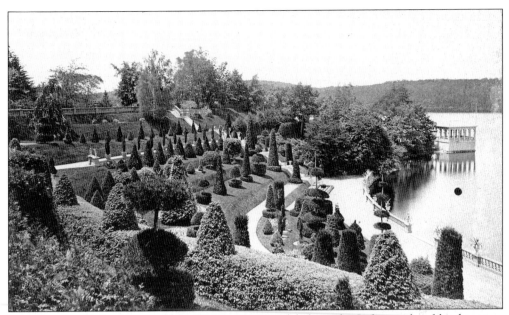

The Hunnewell Gardens on Lake Waban were modeled on the Italian-style of landscaping. Evergreen trees replaced Italian ones due to the New England climate. English trees, rhododendrons, bushes, shrubs, and fruit completed the garden on the 137-acre estate. In addition to the gardens, the estate also had a boathouse, conservatory, stables, and an orchid house. Hunnewell welcomed members of the public to view the gardens on his land.

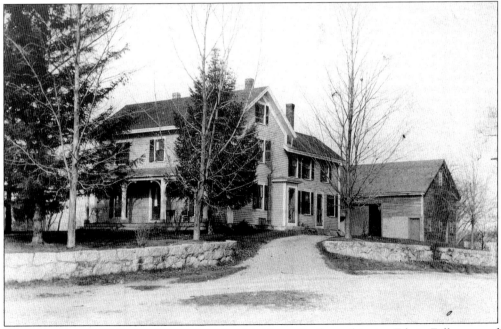

This house at 100 Wellesley Avenue was the third house built on this site. Edwin Fuller, one of the builders of the Wellesley Unitarian church, built the house in 1862. At his death in 1908, his children, G. Clinton Fuller and Ada Fuller Moulton, inherited the home. Ada later gained sole possession of the house and passed it down to her son Robert Moulton.

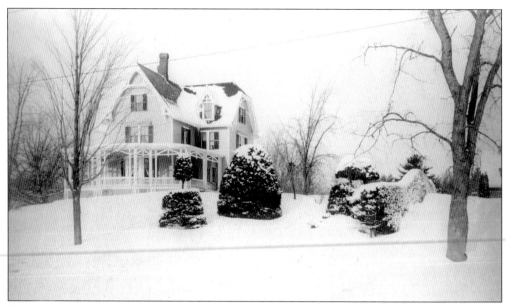

Charles H. Dilloway bought this plot at 535 Worcester Street from George S. Derby on July 10, 1875, and proceeded to build a house. After Dilloway's death in 1911, Walter M. and Grace Farwell bought the estate and lived there with Grace Farwell's sister Annie Morse. Morse left the residence shortly after Grace's death in 1932 and Walter Farwell remained until his death in 1948. (Courtesy of the Wellesley Historical Commission files, Wellesley Historical Society.)

Built in 1880, this home at 86 Benvenue Street was named Appledore because of the property's trees and was possibly the home for the Seth Dewing House's caretaker. Helen Temple Cooke bought the property around 1938 for the Dana Hall School. Phyllis Scorboria lived here as the headmistress of Tenacre School from 1949 to 1972. Once Tenacre became independent in 1973, Dennis H. Grubbs became headmaster and moved in with his family.

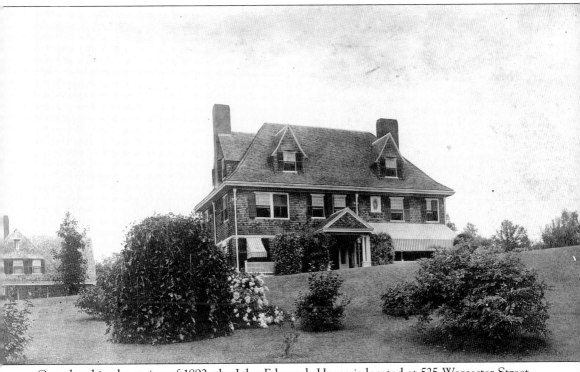

Completed in the spring of 1892, the John Edmunds House is located at 525 Worcester Street. Gamaliel Bradford Sr. sold eight acres of his land to John Shaw, who then sold the land to John Edmunds in 1891. A shoemaker by trade and a former quartermaster sergeant with the Union army, Edmunds bought the property for his retirement. During the house's construction, the Edmunds family lived on Cliff Road. While the Edmunds family lived on Worcester Street, the house was the social center of Wellesley Hills. They employed a coachman, who lived in the carriage house, a cook, who maintained quarters on the second floor, and they also probably hired a maid and a gardener. Edmunds died in 1923, and his sons sold the estate to Maugus Real Estate Trust. The house became a dental office when Dr. Bertram Lubin bought it in 1957 and remained as such until his death in 1968. The Kodaly Music School rented the property from 1971 to 1977.

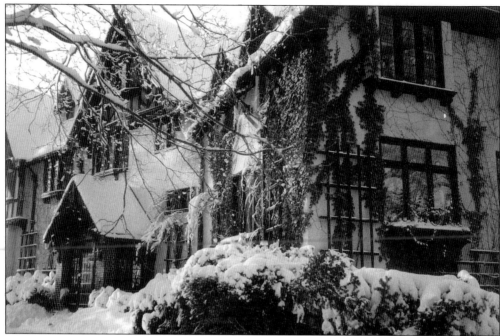

This home at 4 Windemere Lane was built in 1894 by Isaac Sprague V, the first president of the Wellesley Historical Society. It was expanded in 1910 to include a new facade, leaded glass, a library, a breakfast room, a solarium, an elevator, and central vacuuming. The house has about 20 rooms with nine fireplaces spread throughout. The fountain room is decorated in the arts and crafts style, with Tiffany fixtures and Grueby tile on the floor and fountain. The Spragues lived in the house through the Depression, donated the land for the Sprague School and playing fields, and later sold the house to Neil Tillotson of Tillotson Rubber. In 1955, a developer subdivided the land to create both Windemere Road and Windemere Lane. The Chellis family purchased the home in 1959 and it remains in the family to this day. (Courtesy of Robert Chellis.)

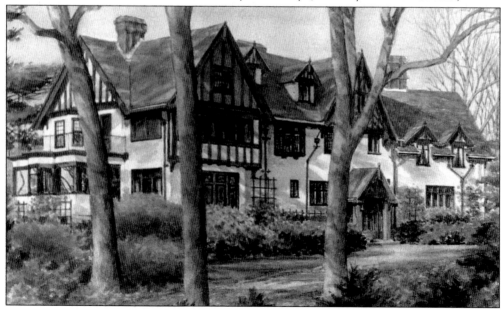

G. Clinton Fuller, postmaster of the main post office in Wellesley Square, was the original owner of this home at 11 Great Plain Avenue. His father, Edwin, deeded the land to him and he built the house in 1897, three years after his marriage to Harriet Eaton. He was one of the descendants of Thomas Fuller, an original settler of Contentment Valley in 1635, which was later renamed Dedham. The Fuller family owned land around Great Plain Avenue, Wellesley Avenue, Washington Street, and Forest Street; these parcels are only part of the family's entire holdings. The Fuller property fell within the current boundaries of Needham and Wellesley. After Fuller's death in 1940, his daughter Katherine inherited the house, which she sold in 1945 when she married and moved to New Hampshire.

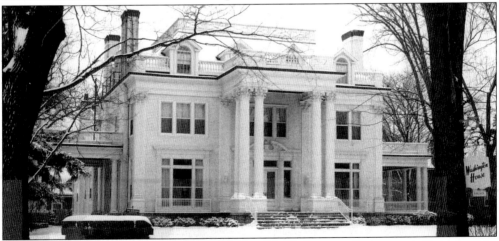

Known as Washington House, this mansion at 600 Washington Street was built in 1904 by Edward H. Ryan so his daughter Bertha could attend the Dana Hall School and Wellesley College while living with her parents. Katherine and William B. Johnson lived here from 1913 to 1917. William was a contractor and built a recreation room in the basement and removed the partition between the two first-floor parlors at the south end of the house to create a room for dancing. The college purchased the house in 1918, transformed it into a freshman dormitory, and named it Washington House. The structure has been rezoned as a private residence after being part of Wellesley College for many years. (Photograph by Roy F. Whitehouse.)

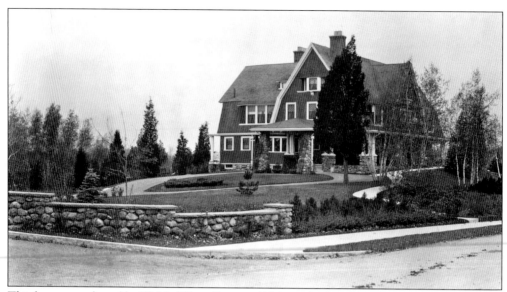

This home, purchased by Waldo Elliott Pratt in 1904, was built in 1902 by a Mr. Shirmer for his French bride. She soon decided that she did not like Wellesley and returned to Paris. Shirmer sold the house with about five acres of land to Pratt for approximately $15,000. Pratt remained in the home with his wife, Ina, and family until his death in July 1931. While they lived in the house, they employed the cook and maids shown in the photograph below. These women were likely Irish or Scottish. In September 1931, the Pratts' son W. Elliott Pratt Jr. moved his wife, Virginia, and family into the house. They remained there until 1954, when he sold the home to Dr. Robert Arnot. The Arnot family remained in the house until 1971, when Stanley Pratt, son of W. Elliott and Virginia, purchased it. The home is still owned by the family today. (Courtesy of Stanley Pratt.)

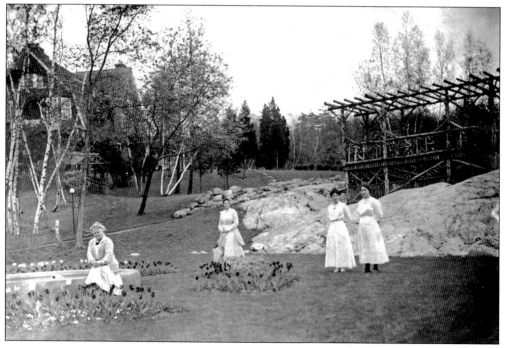

Four

WELLESLEY'S DEDICATION TO EDUCATION

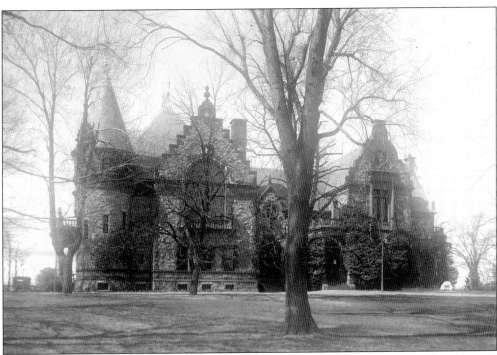

The Wellesley Free Library was completed a year after the town was incorporated and housed in the current town hall building, shown here. In 1959, 700 junior high students and other volunteers performed "operation bookswitch," which transferred books from the Hunnewell building to the Koch building across the street. The newest Wellesley library opened in June 2003 to give patrons more space and to keep up with the current technological demand.

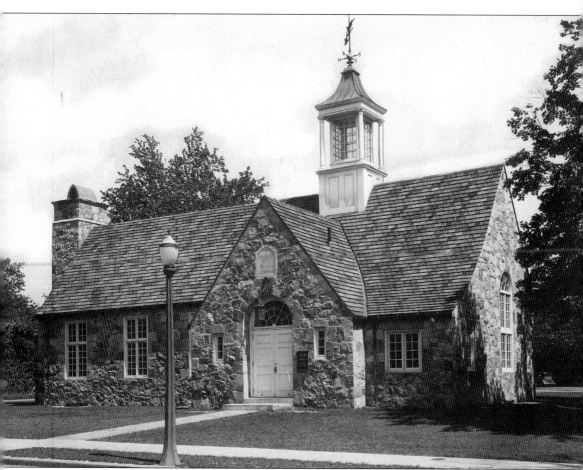

The branch libraries opened to make reading more accessible to residents living on the outskirts of town. Before Wellesley separated from Needham, the Needham Farmers' Library operated out of Alvin Fuller's home in West Needham starting in 1852. The Grantville Library Association started in George D. Ware's house in December 1877, but it closed after H. H. Hunnewell's library opened. Once Wellesley had its own central library, a hired boy carried a basket of books between Wellesley Hills and the main library, delivering returns and picking up new requests. The Fells branch library was built in 1858 as a schoolhouse until the Hardy School replaced it on the opposite side of Weston Road. The Wellesley Hills branch on Washington Street, pictured here, was designed by Wellesley architect Ralph Hannaford and built in 1927. Both the Wellesley Fells branch and the Wellesley Hills branch closed June 30, 2006, but community members are working to reopen them.

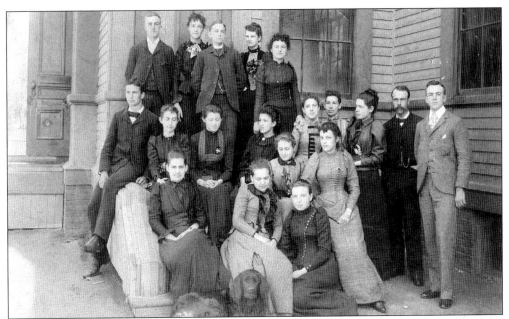

The first Wellesley High School class met in May 1865 with fewer than three-dozen students. The school originally operated in Maugus Hall, which was an old railroad house that had become a public meeting place in Grantville. Before entering high school, students went to four years of primary school and four years of grammar school. Once in high school, they learned Greek, Latin, French, German, English, history, and math.

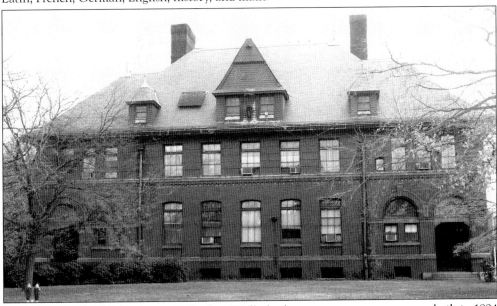

Wellesley's first high school, post-1881 when Wellesley became a separate town, was built in 1894 on Washington Street. Since 1862, the General Court of the Commonwealth of Massachusetts had required that all towns with 500 or more families have a high school. Before Wellesley separated from Needham, there had been two high schools in Needham, one in the eastern part of town and the other in the western part. The Gamaliel Bradford Senior High School was dedicated in 1938.

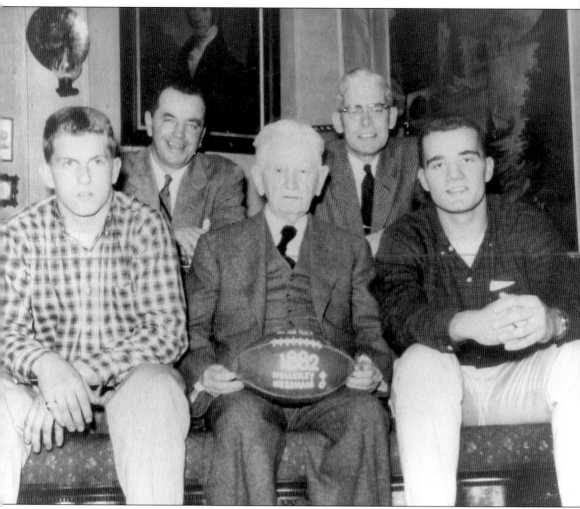

The first Needham-Wellesley football game took place in 1882 at Hunnewell Park. The rivalry between the teams began with Arthur Oldham, father of fan collector Esther Oldham, and is the oldest such rivalry in the country. Oldham took the challenge from Wellesley to Needham via horse and buggy. He was Wellesley High School's first quarterback of the football team. In 1909, one of Oldham's teammates wrote to the *Wellesley Townsman* to recount his memories of the first Wellesley-Needham football game. "There were no long weeks of practice, no coaching, no signals, in fact almost nothing that is now thought necessary for the modern game of football." He also wrote that the Needham boys appeared to be bigger, but the Wellesley boys were able to persevere. Pictured here at age 90, Oldham is holding a football given to him by the Wellesley High football team's cocaptains in 1957.

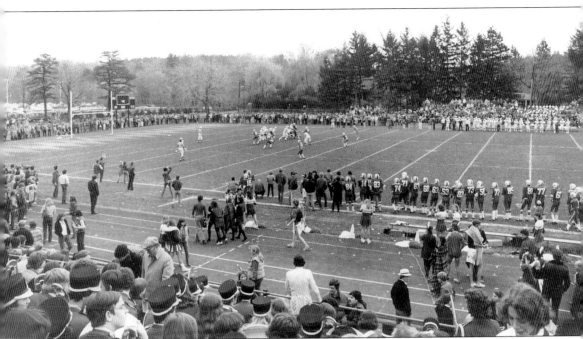

Wellesley won the first Thanksgiving game, beating Needham four to zero. In the early days, the boys each chipped in a quarter to buy a football, which cost between $3 and $4. Inclement weather did not deter the early players. In 1887, they played the Thanksgiving game in temperatures ranging from 11 to 2 degrees below zero. The team did not play in uniforms until the 1888 season. The games have continued every year since, with the exception of the years during the two world wars. Coach Bill Tracey of Wellesley, a 1976 graduate of the high school, said in 1986, "Even though the big majority of the boys will never go on to play football again, all their lives they'll be able to say that they did this one thing—play in the oldest rivalry in the whole country."

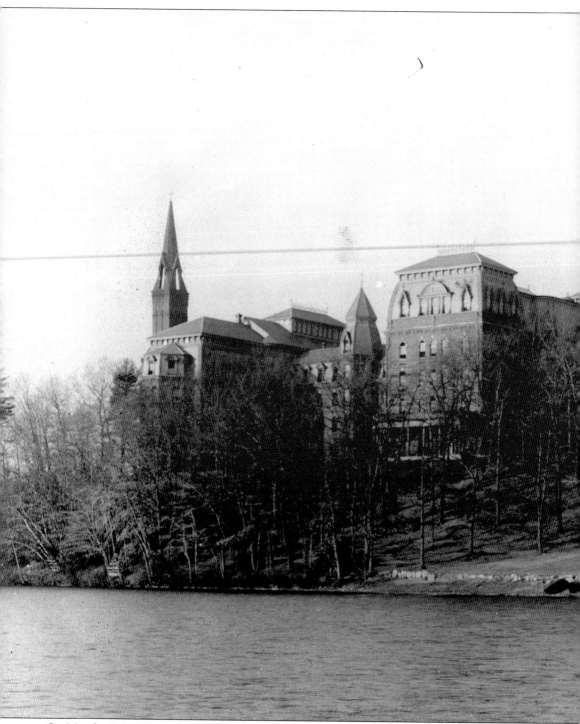

On March 17, 1870, Gov. William Claflin signed the charter for the Wellesley Female Seminary, a school founded by Henry Fowle Durant, who recognized the importance women's education. According to author Florence Converse, Durant "wished to give the teachers and students of Wellesley an opportunity to show what women, with the same educational facilities as their

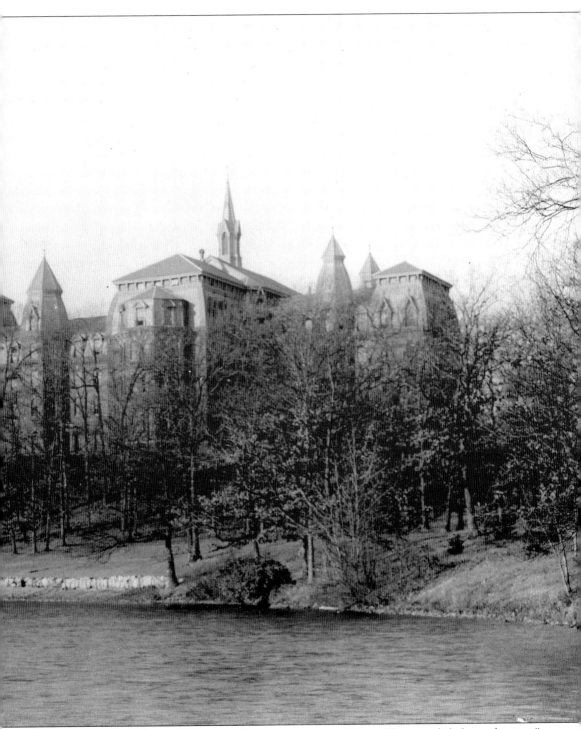

brothers and a free hand in directing their own academic life, could accomplish for civilization."
The cornerstone was laid on September 14, 1871, and the first class arrived September 8, 1875.
Until it burned down in 1914, College Hall was the main building on Wellesley's campus.

Henry Fowle Durant wanted Wellesley College students to have the best education possible. The school had its own physics laboratory in 1878, which predated the existence of such a laboratory at Harvard College. The college women were expected to dedicate themselves to religious pursuits in addition to academic ones. Students were also encouraged to do social work in the community. This photograph was given to the Wellesley Historical Society by the Wellesley College Office for College Relations.

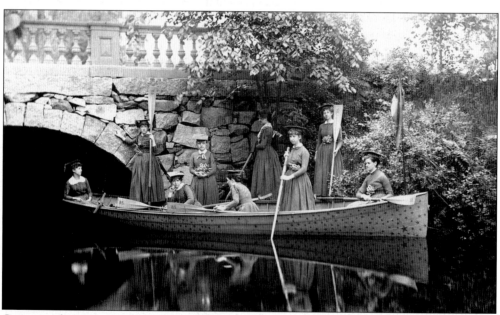

Crew was the most popular sport at Wellesley College in its early years. According to an 1895 edition of *Ladies' Every Saturday*, "The sport has now become so popular at the college that the crew began training on rowing machines in February each year." In 1893, college president Helen Shafer declared that rowing was not a race. "It is not for speed, but for skill and grace."

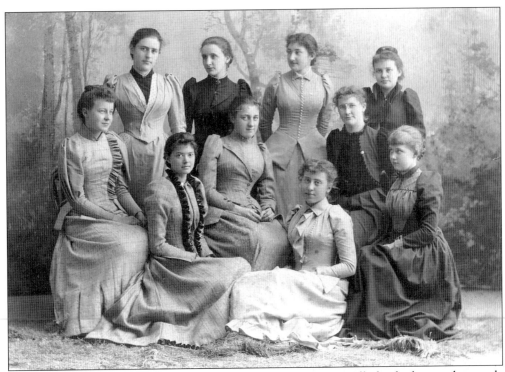

When Durant discovered only 30 of the first 314 students at Wellesley had arrived properly educated, he instituted a college preparatory department, in the old Congregational church Charles Blanchard Dana purchased. The Dana building later became a separate school, founded on September 8, 1881, and run by sisters Julia and Sarah Eastman from Wellesley College. In its early days, the school was advertised as a "Fitting School," which meant it was college preparatory. The one-room school was partitioned for different classes until a private home hosted geometry and classics classes during the first year. In 1882, the Eastman sisters were able to expand the campus and double the enrollment. By 1893, Dana Hall had 78 boarders and 38 day students.

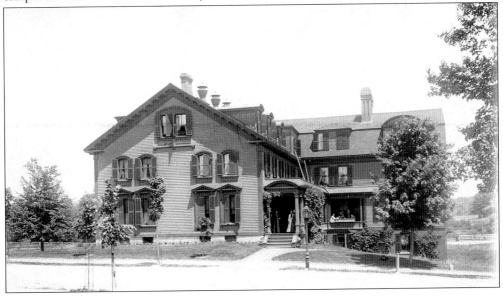

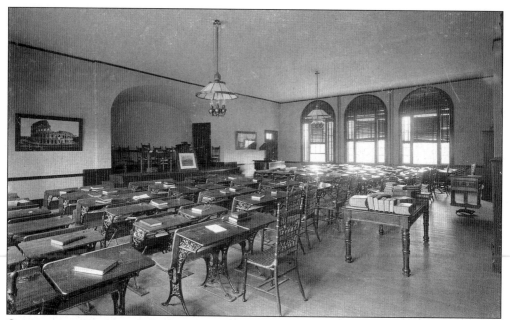

Quarters were snug during the first year at Dana Hall. Mrs. Clarke of Flagg's Tavern invited the school to use her property for some classes during that year. The south wing of the school was complete by September 1882, which included additional classroom space and a gymnasium. Above the classrooms were dormitory rooms, which allowed more students to live at the school. Pictured here is the assembly hall.

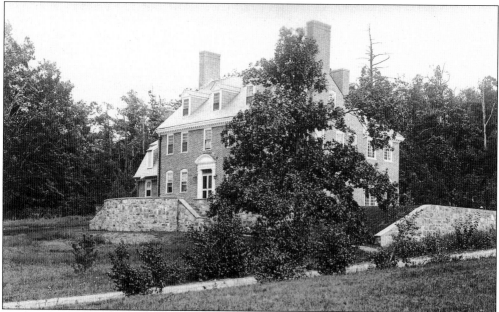

When a group of Dana Hall seniors asked Helen Temple Cooke if they could remain at the school for another year, Cooke created a postgraduate school on-site. The girls stayed at Pine Manor House and Eastman Lodge and shared faculty members with Dana Hall. By the early 1960s, Pine Manor was ready to expand. The school purchased the Dane estate in Chestnut Hill and opened an independent two-year college.

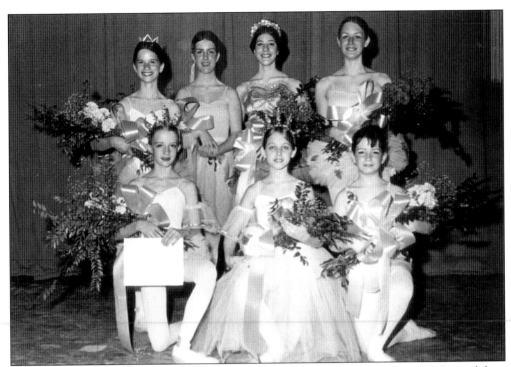

The Tenacre Country Day School opened in 1910 in response to the community's need for a private elementary school. It is one of the oldest independent elementary schools in the United States. The school began as part of the Dana Hall School, educating girls in grades one through nine. When Dana Junior opened in the 1950s, grades seven through nine went there and Tenacre housed prekindergarten through grade six. While it had started as a boarding school for older children and a day school for the younger ones, Tenacre became a coeducational day school in 1952. In 1972, Tenacre became independent from Dana Hall.

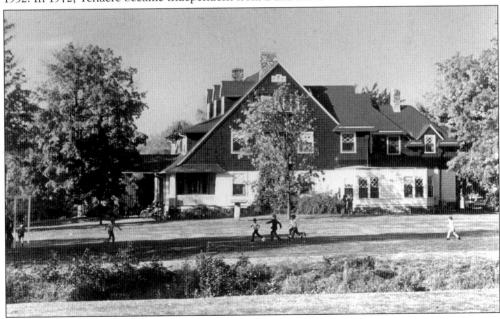

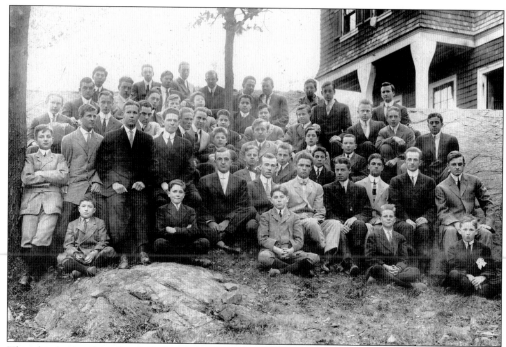

The chief aim of the Rock Ridge School was "to fit boys for the great responsibilities as well as for the great opportunities of American life." Pictured here around 1911 is Rock Ridge Hall, the main school building. It housed reception rooms, an assembly room, the library, a reading room, the office of the headmaster, and accommodations for 35 boys and two masters. The campus also had a recreation building with two bowling alleys, a gymnasium, and a swimming pool. Hawthorne House and Senior House were dormitories that could accommodate 15 boys and 20 boys, respectively. All rooms came furnished.

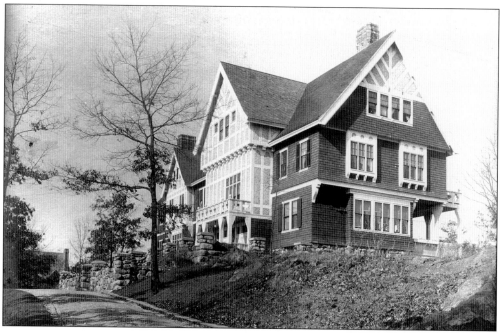

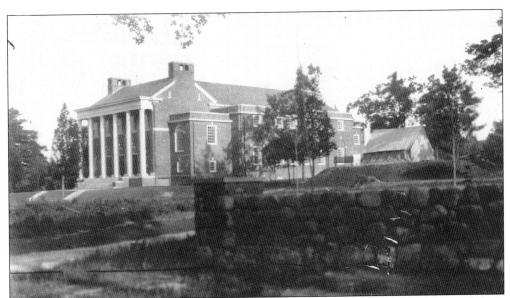

Babson College began as the Babson Institute of Business Administration in 1919 at Roger Babson's home on 31 Abbott Road. Before opening the school, Babson had an investment counseling service and worked as a statistician. Soon after the institute's founding, Babson relocated the school to the Stuart building at 320 Washington Street. The building pictured here is on the school's current campus on Forest Street. The institute became Babson College in April 1969.

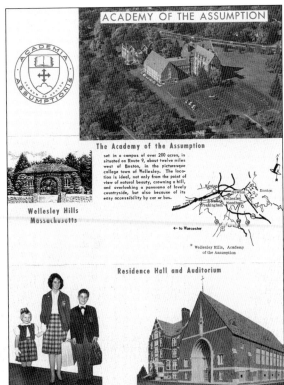

In 1893, the Sisters of Charity purchased the Scudder mansion and opened the Academy of the Assumption, a school for girls. The academy was renamed the Elizabeth Seton High School for Girls in 1963. After the academy closed, Massachusetts Bay Community College moved to the campus from Watertown. Since 1973, the college has provided educational opportunities for students in the western suburbs.

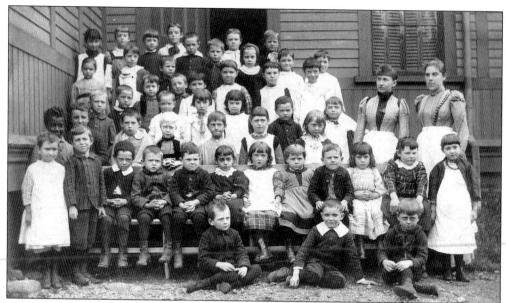

After Needham was split into districts, a three-man committee ran each district and had to provide a teacher for each school and supply wood to heat the school. The student population increased after the Longfellow woods section of town became developed. This prompted the building of a second school in the area, the Seldon L. Brown School, which subsequently decreased the attendance at the North School, the school where the students pictured above attended and at which the teachers below taught. The 1874 school signaled the changing trend in education toward graded schools. The previous three buildings on this site had been moved and converted into homes. After the North School closed, the Annie F. Warren School was built in 1935. Today it is known as the Warren Recreation Center. From left to right, the teachers are (first row) Miss Holmes, Principal Miss Warren, and M. Valentine; (second row) M. Rhoades, C. Clark, and Nellie Coleman Burke.

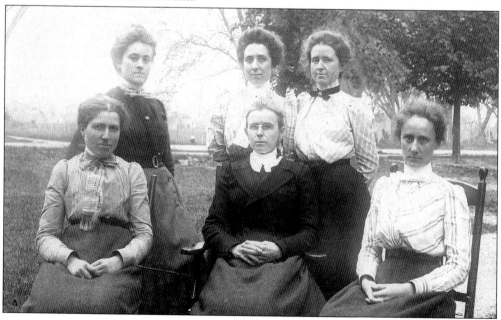

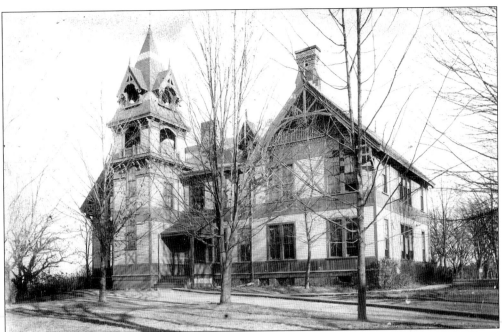

The North School was the first schoolhouse erected while Wellesley was still a part of Needham. The North School district in Needham formed in about 1785. In 1795, the town voted to pay £75 for a schoolhouse in the Lower Falls. The North School pictured here was built in 1874 and enlarged in 1894. Other schools had existed on this site in 1858, 1840, and before.

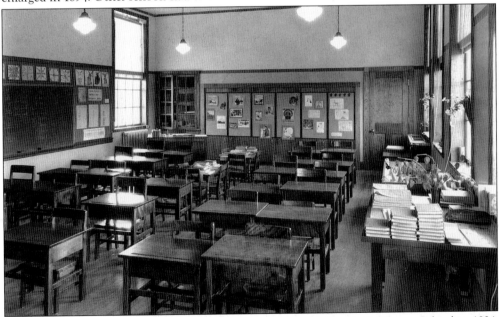

After the North School was razed, construction began on the Annie F. Warren School in 1934. Warren had been a Wellesley resident, and graduated from the North School, West Needham High School in 1879, and Boston University. She taught at the North School beginning in 1885 and remained in the school system until 1920. The Warren School had 12 classrooms, two kindergartens, and a state-of-the-art sound system for its time. (Photograph by Cosmas V. Cosmades.)

The Kingsbury School was named for school committee member L. Allen Kingsbury, who gave several acres of land for a parkway, a portion of which was used for the school grounds. Originally it was the Belvedere School, named for the housing development between Forest Street and Abbott Road. The school was erected in 1924 and remained an elementary school for 50 years. After closing in 1975, the building was briefly considered as an annex for the high school. In order to become a suitable annex, the building needed to become handicapped accessible and brought up to safety codes. The building had also suffered damage from a fire in 1974. The school committee turned the school over to the town in 1977 after deciding that the building could not be used. The school was later converted into condominiums in the early 1980s. (Photograph by George Young.)

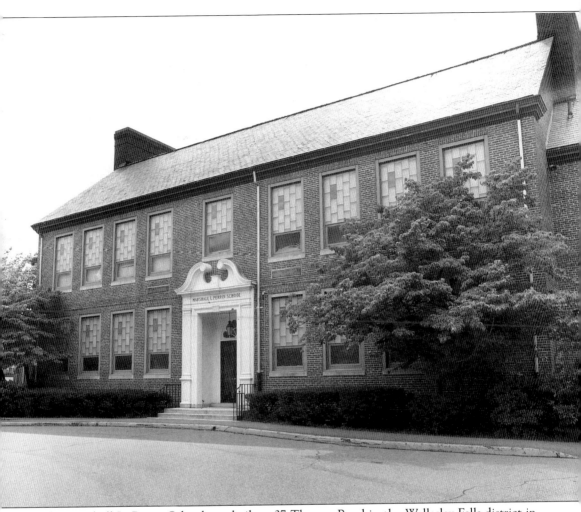

The Marshall L. Perrin School was built at 37 Thomas Road in the Wellesley Fells district in February 1932. It opened with kindergarten and the first three grades. The Perrin School had two predecessors in the same district, the Fells and the Hardy Schools. The third school was named for Marshall L. Perrin, an 1870 graduate of West Needham High School. Perrin was born in Grantville on July 31, 1855. He graduated from Harvard College in 1874 and went on to become a German instructor at Boston University. He was superintendent of the Wellesley schools from 1893 to 1909. Perrin believed that education "enables us to make the most of ourselves and to help others do the same." The Perrin School remained open until 1981 and the building burned down in 1984. (Photograph by Mike McAvoy Photo of Wellesley Hills.)

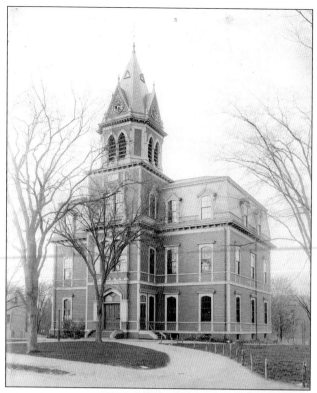

The Shaw School and its assembly hall were built in 1875 at the corner of Forest and Washington Streets. Alice L. Phillips taught all grades at this school. Between 1869 and 1875, high school classes took place during half of the year. The upstairs hall served as a meeting place for dancing parties, dance classes, and other entertainment. The clock and bell from the Shaw School were preserved in the Isaac Sprague Memorial Tower, erected in Elm Park in 1928; John Shaw had given the clock to the town in 1864. The Shaw School became condemned in the early 1900s and was no longer a school after the Alice L. Phillips School opened in 1911. Around 1926, the Shaw School was torn down to make way for the Community Playhouse.

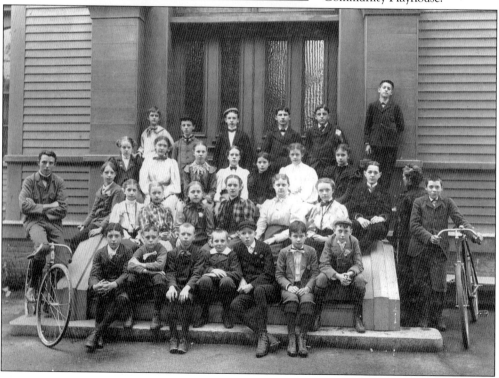

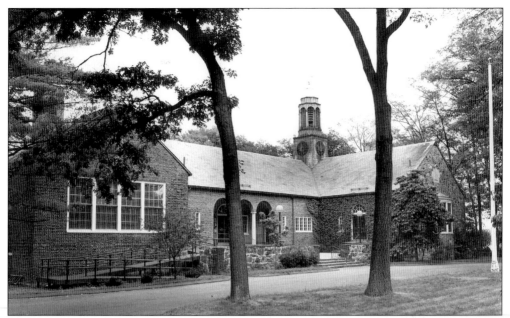

The original Sprague School was named for Isaac Sprague, the president of the Wellesley National Bank and son of the botanical artist. Sprague donated the land and stone for the Wellesley Hills Branch Library and gave the land for the Sprague School. A new addition was constructed in 2001 with many all-purpose rooms and a new library. (Photograph by Mike McAvoy Photo of Wellesley Hills.)

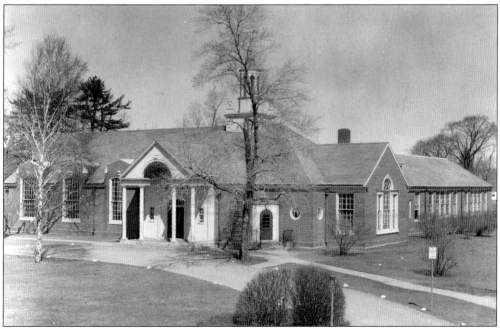

The first Hunnewell School was also known as the Fiske House and was built in 1844. It was replaced around 1893 by a new schoolhouse given by H. H. Hunnewell. The old school was moved to Wellesley College, where it was remodeled. This photograph shows the new Hunnewell School built in 1938, which was the third Hunnewell School in Wellesley.

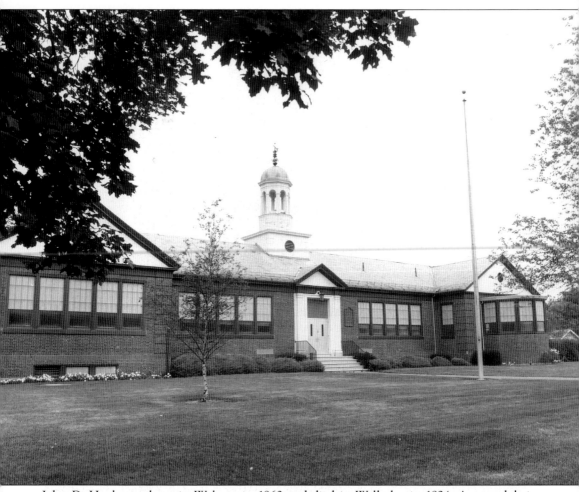

John D. Hardy was born in Woburn in 1860 and died in Wellesley in 1924. As an adult in Wellesley, Hardy was socially active. He was a member of the Wellesley, Maugus, Country, and Twentieth Century clubs and the American Academy of Political and Social Science. Hardy was the director and a member of the executive committee of the Wellesley Co-Operative Bank and the chairman of the building committee that built the schoolhouse at 293 Weston Road. The John D. Hardy School opened in November 1923 after the Fells School closed. From the very beginning, the Hardy School was overcrowded. Fourteen months after its opening it already needed an addition. After 1925, each grade had its own room until 1932, when decreased enrollment led the school to consolidate space. Eight more classrooms and an all-purpose room were added in 1956. (Photograph by Mike McAvoy Photo of Wellesley Hills.)

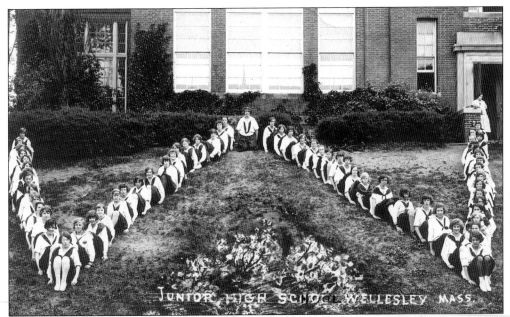

One of the first junior high schools organized in Massachusetts was located in Wellesley Hills. Students were divided into seventh, eighth, and ninth grades and taught by teachers who specialized in the subjects they were teaching. The Alice L. Phillips School became a junior high school in 1919. A new junior high was built on Kingsbury Street in 1949 and opened in 1952 with 29 general-purpose classrooms.

The junior high school had many different club organizations. The clubs were designed to help students develop qualities of leadership and responsibility, to work with others, and to produce "an atmosphere of happiness among boys and girls," according to the *Wellesley Townsman* of April 1934. Among the clubs were the Phillips Junior Congress and *The Phillipian*, the school magazine. Shown here is the Paper Club in 1929.

During the first half of the 20th century, the junior high female athletes had a two-and-a-half acre playfield while the boys played on a three-and-a-half acre field. These fields allowed the students to have a year-round program of recreation and physical education. In February 1958, the Junior High Addition Committee voted to have a new wing added that included a small double gymnasium with a ceiling height of 16 feet. In 1956 at the high school level, girls could choose to play field hockey, softball, basketball, and tennis as part of their extracurricular activities. In class, they practiced badminton, tumbling, archery, and golf. In contrast, boys generally played the same sports they do in the 21st century, including football, hockey, basketball, wrestling, baseball, track, cross country, indoor track, swimming, skiing, gymnastics, tennis, and golf. In their classes they played speedball, badminton, volleyball, and soccer. (Photograph by Christopher Wiles.)

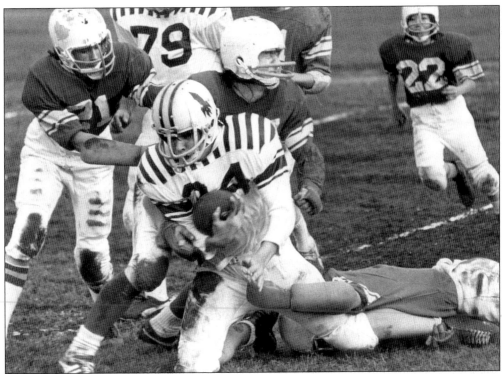

During the 1960s renovations, the girls' locker and shower rooms remained the same, with exception of 250 ventilated basket lockers added. The boys' locker room facilities were expanded and part of the woodworking shop was converted into extra locker space. The junior high had a football team and a cheerleading squad as well as baseball, basketball, hockey, and speedball teams. Other junior high activities included arts and crafts, cartooning, debating, dramatics, photography, and science clubs, a glee club, orchestras, bands, student council, class organizations, and a Red Cross club. (Bottom photograph by Christopher Wiles.)

In the spring 1964 issue of the Wellesley Public Schools' newsletter, *Your Schools*, the music program was described as "a balanced program of music education in which the student, stimulated and challenged, may seek a place for himself and his endeavors." There were two bands, an orchestra, and many choruses organized by grade and voice classification in 1964. The 1956 high school course guide stated that the band and the orchestra would "increase the level of musicianship and . . . offer opportunities for [the] development of higher skills." Students in the musical ensembles have participated in the New England Music Festival, the Wellesley Community Orchestra, and the Greater Boston Youth Symphony. In 2001, Wellesley High School orchestra director Jonathan Girard was recognized by *School Band and Orchestra* magazine was one of the top 50 directors who make a difference.

Five

SOCIAL LIFE

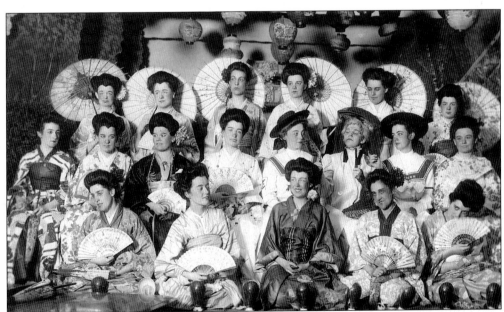

Maugus Hall was originally a public meeting site, and some Civil War–era rallies took place here. The hall also served as a social center, demonstrated by this picture of women presumably putting on a dramatic show. For a short period, it served as West Needham's first high school. After 1871, it was Unitarian Society of Grantville's first church. In 1888, the building became a private home and moved from its location at Wellesley Hills Square to Forest Street.

The Maugus Club was organized in 1892 with Joseph E. Fiske as the first president. The purpose of the club was "the establishment and maintenance of places for social meetings . . . accommodation[s] [for] social and charitable bodies, and [facilities for] athletic exercises." The McLeod block in Wellesley Hills hosted the Maugus Club before it moved to 40 Abbott Road. This building was destroyed by a fire in 1953, but it was replaced and the club continues to operate today.

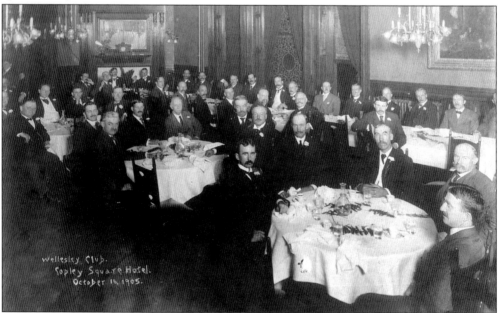

During the 19th century, clubs formed for literary and educational purposes. By the end of the 1920s, there were more than 50 clubs and organizations in Wellesley, including Boy Rangers of America, the American Legion, and the Wellesley Historical Society. Pictured here is the Wellesley Club, founded in 1889 and still in existence, meeting at the Copley Square Hotel in Boston on October 16, 1905.

The Wellesley Hills Woman's Club started in 1890 after a minister suggested that there be a social club for girls. The club later became a prestigious group of leading women, including Dana Hall School headmistress Sarah P. Eastman. The women gathered to hear music, dramatic readings, and lectures. Their activities combined education with pleasure. Most of the social gatherings were held in private homes or at church function halls. (Photograph by Chalue of Needham.)

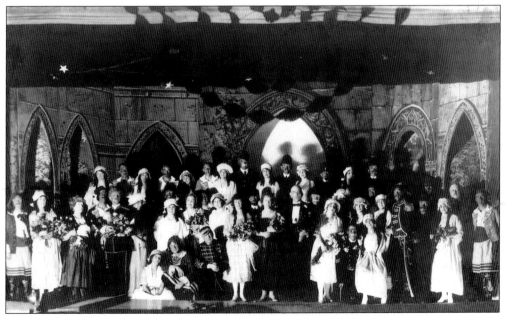

In addition to its social contributions, the Wellesley Hills Woman's Club promoted the arts in the community. The club had art classes, glee clubs, choirs, and choruses. Pictured here is the music department's performance of W. S. Gilbert and Arthur Sullivan's *The Pirates of Penzance*. The club added a dramatic department to its organization in 1907.

Wellesley's involvement in American conflicts dates back to the Revolutionary War. Ephraim Bullard sounded the alarm on April 19, 1775, to gather militia for Lexington from Bullard's Hill, now at Wellesley College. Amos Mills was the only Wellesley casualty that day. Wellesley residents have fought in every major war since. After their return home, modern Wellesley veterans continue their civic duties, supporting youth activities and volunteering at the Veterans Administration hospitals.

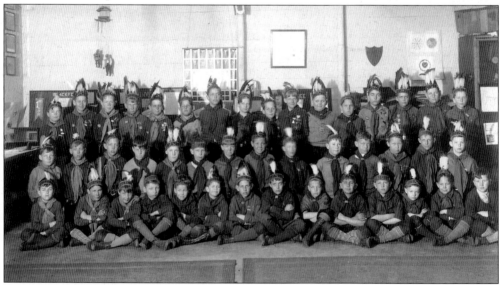

Emerson Brooks founded the Boy Rangers of America as a scouting group for younger boys who were not old enough to join the Boy Scouts, an organization geared toward teenagers. The Boy Rangers focused on Native American customs and values. The Wellesley Boy Rangers celebrated their 55th anniversary in 1981. Eventually, the Boy Rangers were replaced by the Cub Scouts, a division of the Boy Scouts of America.

The Boy Scouts of America was founded in 1910 and started in Wellesley in 1912. According to Thomas Kealy's 1989 article in the *Wellesley Townsman*, adults in the first two decades of the organization's existence believed that scouting would "lead the boy to a full and wholesome enjoyment of the outdoor life [and] teach him to do useful and helpful things." In 2000, Troop 182 celebrated its 87th anniversary at the Wellesley Hills Congregational church. (Photograph by Michael McAvoy Photo of Wellesley.)

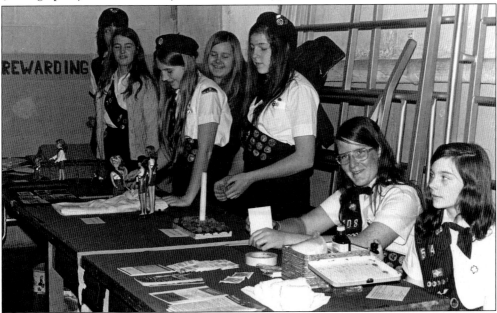

Juliette Low founded the Girl Scouts in 1912 to give girls the opportunity to grow physically, mentally, and spiritually. Mary Bunker started the first troop in Wellesley in 1917. By 1942, Brownie and Girl Scout troops existed in every school or school district in town. Service projects remain a part of Girl Scouting. In 1999, Scouts from the Hunnewell School sent Christmas stockings to flood victims in North Carolina.

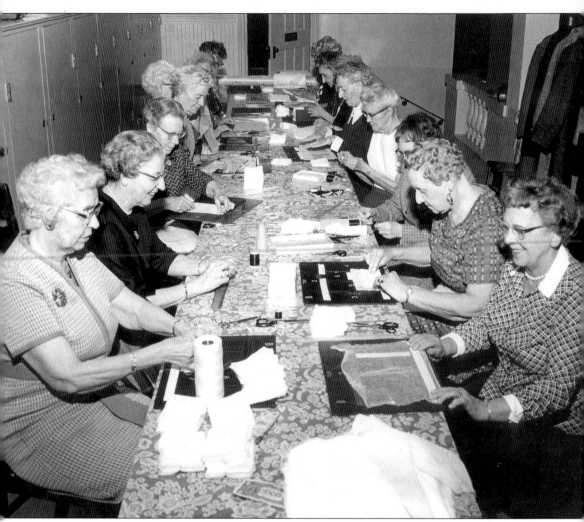

The Wellesley chapter of the American Red Cross was organized on November 14, 1914; it was one of the first chapters in Massachusetts. The chapter was headquartered at the town hall and later the Shaw School before moving to 211 Washington Street in October 1952. During World War I, there were over 3,300 members of the chapter. During peacetime, the Wellesley Red Cross has worked in cooperation with various services organized for the public's benefit. It has organized bloodmobiles, safety programs, CPR courses, first aid classes for Boy Scouts, policemen, and firemen, and transportation for the ill and disabled. (Photograph by Chalue of Needham.)

The Wellesley Community Center was established in 1977 by the Wellesley Jaycees to "meet the needs of senior citizens, young people, non-profit groups, and educational activities." It is a private organization not subsidized by the town of Wellesley and relies on contributions. The center gives office space to non-profit organizations and it also has lecture halls and party rooms. When it opened, one of the popular spaces was the drop-in youth center. The Friendly Aid leases the land to the center for $1 per year. In 1978, the center established the Wellesley award to recognize "the civic and humanitarian contributions of Wellesley residents to the improvement of [the] community." These awards were presented annually until 2004. This photograph shows Mrs. Howard W. Tiberio and Barbara Keenan inside the community center.

The first Exchange Club in the United States formed March 27, 1911, in Detroit as a service organization to help the community. Wellesley chartered its Exchange Club in 1951. The members of the Exchange Club hold positions of leadership in industrial, business, professional, educational, religious, and financial fields. Among the contributions of the Wellesley Exchange Club was Youth in Government Day, during which high school students elected by their classmates to various town meeting positions participated in their town office's business under the supervision of their adult counterparts. The club disbanded in the 1980s.

The Florence Crittenton League of Compassion was incorporated in Boston in 1908 for the care of unmarried mothers. It was an outgrowth of the Florence Crittenton Home Society of Boston, a religious mission with a hospital in Roxbury. The Wellesley circle of the Florence Crittenton League organized in 1921 and the junior circle formed in 1934. Membership in the junior league is limited to 50 active members plus inactive affiliates. This photograph shows members of the junior circle at the league auction. (Photograph by Chalue of Needham.)

Ten women from Wellesley formed the Wellesley Junior Service League in 1927 to organize efforts to provide volunteer service to the community. Initially the members assisted the Friendly Aid in its projects. Over time, they worked with the thrift shop, the Wellesley Hills Exchange Club, and the board of health clinics. Each year, the league's centennial award honors a high school student for his or her community service. (Photograph by Chalue of Needham.)

The first Kiwanis Club began meeting January 21, 1915, in Detroit. The Wellesley Kiwanis Club organized in 1926 as club number 1560. Club members are business and professional people who, under the motto "We build," dedicate themselves to community service. As of 1985, there were over 8,100 clubs and 310,000 members in 80 nations around the world. The Wellesley Kiwanis members sponsor the Key Club at Wellesley High School and the Circle K clubs at Dana Hall and Wellesley College, high school scholarships, and the Special Olympics. The Wellesley Kiwanis received their first female members on September 17, 1987. (Photograph by Chalue of Needham.)

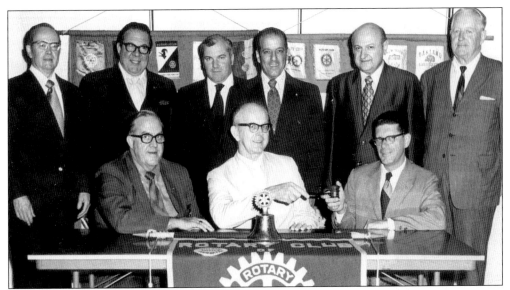

The oldest service organization in the world, the Rotary Club was founded in 1905 by attorney Paul Harris in Chicago. Wellesley's Rotary Club was founded in 1946. According to the *Wellesley Townsman*, "Rotary is an organization of business and professional men and women united worldwide to provide humanitarian service, encourage high ethical standards . . . and promote international understanding and peace." Locally, Rotary sponsors the Little League Pancake Festival and college scholarships for Wellesley High School graduates. (Photograph by Chalue of Needham.)

Chicago businessman Melvin Jones thought that business clubs needed to broaden their focus to include working for the community and world at large. After Helen Keller addressed the club in 1925, the Lions Clubs have been devoted to helping the blind and visually impaired. The Newton Lions Club sponsored the Wellesley chapter, which was organized at the Wellesley Inn on December 28, 1949. The Wellesley chapter has since disbanded. (Photograph by Christopher Wiles.)

The Wellesley Garden Club, founded in 1929, started as a committee of the Wellesley Hills Woman's Club. While promoting town beautification, the club also seeks to provide service to the community in the conservation of natural resources. The garden club has exhibited at the New England Flower Show since 1932 and has designed and executed many gardens for the town, including the one at the Wellesley Historical Society. (Photograph by Chalue of Needham.)

The House and Garden Club of Wellesley was founded in 1958 with its membership limited to 45 Wellesley residents and 20 sustaining members. This club seeks "to encourage active interest in horticulture and conservation among amateur gardeners and to further the knowledge of beautifying town and home." This is one of five garden clubs operating in 21st-century Wellesley. (Photograph by Chalue of Needham.)

Three young Wellesley women who wanted to form a dynamic garden club started the Gardeners' Guild in 1968. This club focuses on basic, general gardening knowledge and encourages interest in all phases of home gardening. They maintain the window boxes at the Wellesley post offices and have an annual holiday fund-raiser, Deck the Halls, which gives the winner the opportunity for his or her house to be decorated for the holidays. The club also donates and plants flowers near the Warren School site. A small club of 30 women, the Gardeners' Guild joined the Federation of Garden Clubs in 1970. In April 2002, the guild and the Round Table Garden Club joined four other Wellesley garden clubs to have an English flower festival at St. Paul church. They created topiaries, candle decorations, pew arrangements, and a six-foot flower arrangement on the altar. (Photograph by Chalue of Needham.)

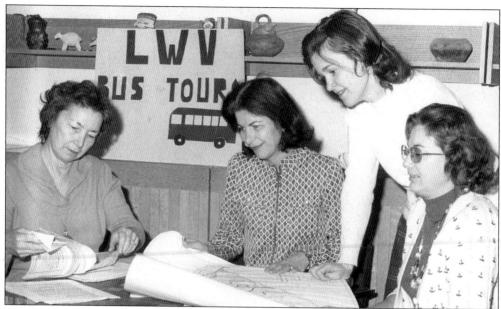

The League of Women Voters is a nonpartisan organization founded at the national level in 1920 after women received the right to vote. The first order of business was to educate 20 million women about how to vote. The Wellesley chapter of the league started in 1938. According to their club booklet, "The purpose of the League of Women Voters of Wellesley shall be to promote political responsibility through informed and active participation of citizens in government." The Wellesley league publishes the *Wellesley Handbook* and the annual election guide, assists the town clerk with voter registration, and provides rides to the polls for every election. Through advocacy and education, the league seeks to increase awareness about public policy issues. (Above, photograph by Michael McAvoy Photo of Wellesley; below, photograph by Chalue of Needham.)

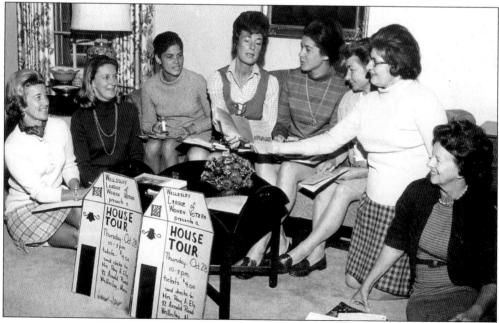

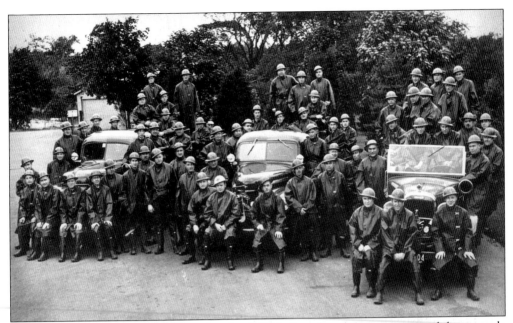

The Wellesley Fire Department started in April 1886 when the selectmen appointed three people to serve as fire engineers. The hose one house on Church Street was the first headquarters for the town's volunteer fire brigade. Before automobiles, fire horses resided at Diehl's Livery Stable at Crest and Central Streets. The stone fire station at the corner of Weston Road and Central Street was completed in 1929. This is the auxiliary fire squad from the World War II era.

Founded in 1948, the Wellesley Symphony is currently the orchestra-in-residence at the Massachusetts Bay Community College. The symphony has regular concert performances that boast well-known soloists and feature Boston-area television personalities as hosts. In 1958, Arthur Fiedler was the guest conductor for the orchestra's 10th anniversary celebration. In 2001, the orchestra performed Wellesley resident Julia Scott Carey's composition, "Sabrina Lake Sketchbook" inspired by the man-made body of water formerly on the Baker Estate. This photograph shows conductor Robert Prins and the Wellesley Symphony Orchestra preparing for its 1974 pops concert. (Photograph by Donald V. Hay.)

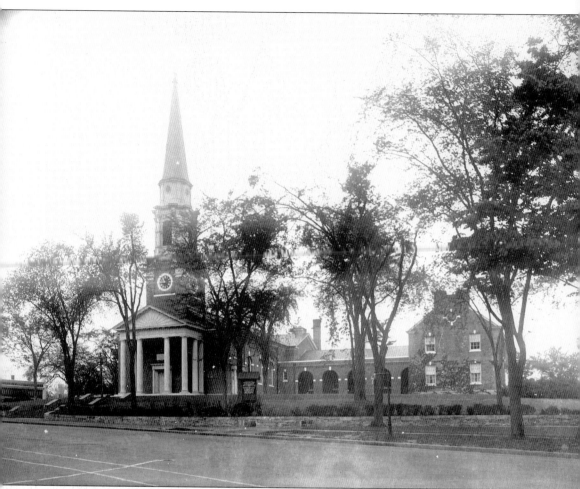

Rev. William F. Anderson preached the dedication sermon of the fourth Wellesley Congregational church on October 21, 1923. It replaced the third church that had burned down December 31, 1916. In 1955, a new wing was added to the church on the cemetery side. The congregation hosted visitors from the Soviet Union in 1983 as part of Bridges of Peace, a United Church of Christ effort to promote a dialogue between American and Soviet citizens to reduce the threat of nuclear war. Renovations in 1988 made the church handicapped accessible and added some new amplifying technology. During a 2002 construction project, excavators found bones in the old cemetery that likely dated to the 18th century. This discovery was made while contractors were trying to bring together the church and adjacent cemetery. This church continues to stand in Wellesley Square.

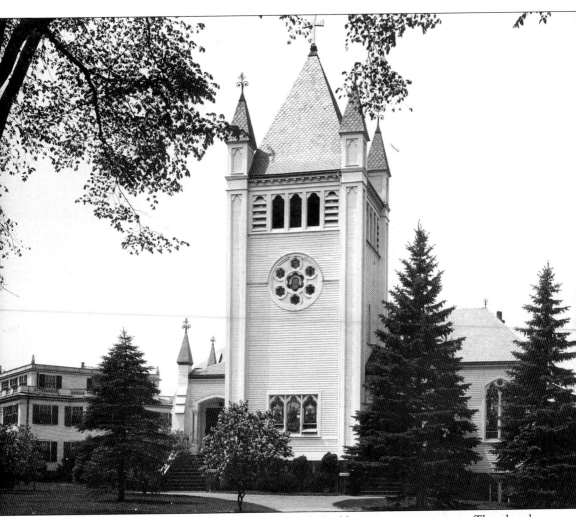

St. John the Evangelist is Wellesley's oldest church building in continuous use. The church was built because of the increase in the number of parishioners attending St. Mary's Church in Newton. Archbishop John J. Williams purchased two acres of land on Glen Road in Wellesley for the Archdiocese of Boston to build a church as a mission of St. Mary's. Construction was completed in 1874, the church celebrated its first mass on May 1, 1875, and the building was formally dedicated in 1881. The church became independent when Rev. Patrick Callanan was appointed in 1890. In 1906, St. John's established a mission at St. Paul to accommodate the people of western Wellesley. Since its foundation, the St. John the Evangelist church building has been expanded (1900), remodeled (1957), and renovated (1998) to grow with the congregation.

St. Paul Church originally met in the Boys' Club on Central Street before moving to a room over a garage on Cameron Street. Rev. Leo Knapp, pastor of St. John the Evangelist, purchased land for St. Paul in 1914. The parish broke ground for a new church on Washington Street August 10, 1915, and Cardinal William Henry O'Connell formally blessed the church on November 12, 1916. The church was a mission of St. John the Evangelist until 1922. Before St. Paul opened, Catholics in Wellesley Square traveled to Natick or Newton Lower Falls for Sunday mass. Keeping up with the tradition of its former mother church, St. Paul established a mission at St. James Church in 1947 to serve the Wellesley Fells population. (Photograph by Chalue of Needham.)

St. James Parish Church was established September 20, 1950, for Catholics who lived in Wellesley Fells and East Natick. Before the church building was erected on Worcester Street, the congregation met in an army chapel from Windsor Locks, Connecticut. The original church was dedicated October 25, 1947, and Rev. Cornelius F. O'Leary was appointed the first pastor.

Before the Trinity Alliance occupied this site at 348 Weston Road, other congregations had existed here. The Massachusetts Universalist Convention purchased the property in 1944 and built a small church. At least two other religious groups used the facilities along with the Universalist congregation in the late 1960s. The Christian and Missionary Alliance denomination bought the church in 1969 as meeting place for its new congregation.

According to Dr. E. E. Bancroft, the Episcopal Church held services in West Needham as far back as 1875 in the old Waban Hall in Wellesley Square. St. Andrew's descended from a church of the same name in Plymouth, England. After 1887, services were held in the town hall until St. Andrew's was created in 1894. (Photograph by Robert W. Chalue.)

Wellesley College students organized a Christian Science reading group in a studio on Church Street in 1903. The group formed the Wellesley Christian Science Society on September 10, 1908, in accordance with the bylaws established by Mary Baker Eddy. Members of the society met in February 1919 to establish the First Church of Christ Scientist and held their first service in a new building in 1927.

Twenty-two women founded the Jewish Community Group of Wellesley in the fall of 1949 to stimulate social, cultural, and religious activities and acquire a community center in Wellesley. The group broke ground on their own temple on Cedar Street in 1960, after having shared space at the Universalist Church. In 1958, the community group had incorporated under the name Temple Beth Elohim and became affiliated with the Union of American Hebrew Congregations. During this year, the new congregation expanded their religious education with a Hebrew school and three youth groups. In the spring of 1981, Temple Beth Elohim began construction on expanded facilities to accommodate 263 member families. Members of the synagogue are dedicated to serving others. Immediately after the cold war ended, they partnered with a Jewish congregation in Odessa, Ukraine, to help revive religious traditions in the former Soviet state. In May 1998, the congregation had its first annual Mitzvah Day on which they performed community service projects in the Boston area. (Photograph by Chalue of Needham.)

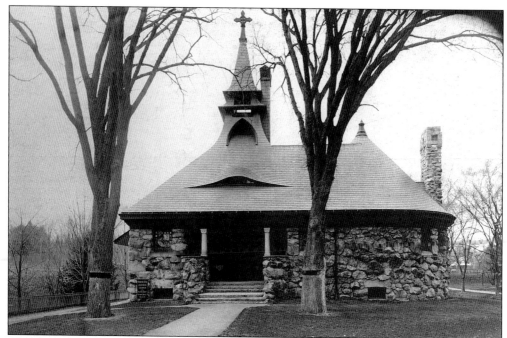

The Unitarian Society assembled in 1869 and legally organized as a corporation on February 27, 1871. During its first year of operation, the society purchased Maugus Hall and used it as a meetinghouse. The society was reorganized on December 20, 1877, under the act of incorporation as the Unitarian Society of Grantville. Rev. Albert Buell Vorse served as the first minister from April 3, 1871, to January 21, 1899. In June 1885, the society changed its name from the Unitarian Society of Grantville to that of Wellesley Hills. In 1888, the stone church was dedicated. New church schoolrooms were added in 1950 and a new nave was constructed in 1960.

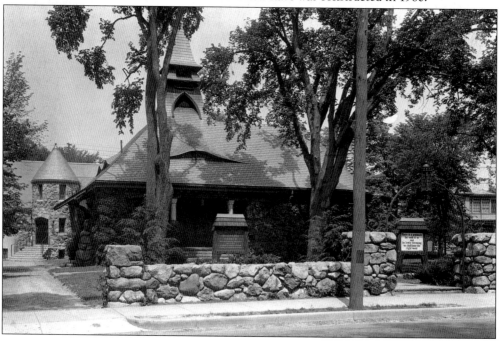

Six

LOCAL ENTERPRISE

William O. Grover, a Boston tailor, wanted a business partner to help him develop and market a sewing machine, and William Emerson Baker was a salesman fit for the task. The two men became partners in 1850 and opened the Grover and Baker Sewing Machine Company at Haymarket Square in Boston. When Baker retired in 1868, he purchased land in the southwest corner of Needham where he created Ridge Hill Farms.

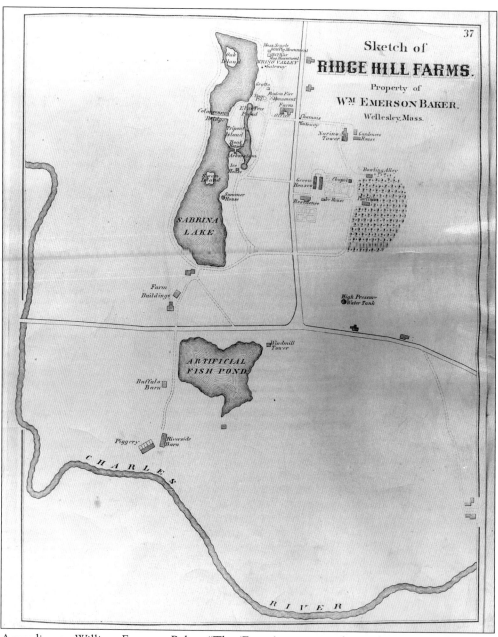

Sketch of
RIDGE HILL FARMS.
Property of
Wᵐ EMERSON BAKER.
Wellesley, Mass.

37

According to William Emerson Baker, "The 'Farms' . . . curiously combines art with nature, quaint history and comical amusements." Also known as the Baker Estate, Ridge Hill Farms had live animal exhibits, bear pits, a museum, conservatories, greenhouses, a saloon, a bowling alley, and a private chapel. The Hotel Wellesley operated on the Baker Estate from 1878 to December 19, 1891, when it burned down. The hotel had three main floors and a huge garret with 159 guest rooms, a dining room that seated 600 guests, a billiards room, two bowling alleys, a music room, and a large gymnasium. Guests could stay at the hotel between June 15 and October 15 when the Ridge Hill Farms were open. Ridge Hill Farms spread over 755 acres at the junction of Charles River and Grove Streets in Needham. After 1881, 125 of these acres ended up in Wellesley.

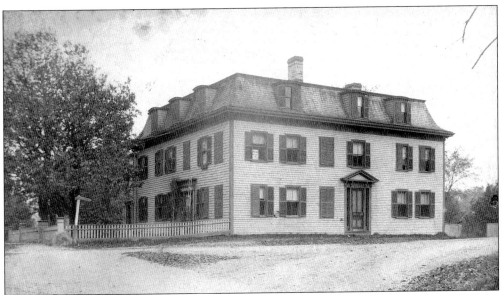

Located at the corner of Washington and Church Streets, Flagg's Tavern stood in Wellesley Square for more than 150 years. George Washington reportedly stopped at the tavern during his trips between New York and Boston. In the mid-19th century, William Flagg was the tavern keeper, the second postmaster, and owner of a village store. When this photograph was taken around 1880, Flagg's son, William Henry Flagg, was proprietor.

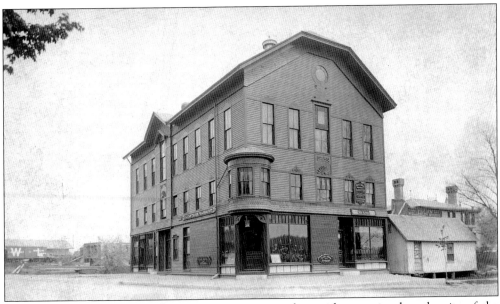

According to a map of Needham, a variety store and a residence existed at the site of the Shattuck block in Wellesley Square in 1856. F. W. Shattuck owned the land as of 1886. By 1889, Shattuck was assessed $9,000 for a store building on Washington Street. The Sincerity Lodge rented the third floor until 1919, and the post office operated out of the block on the Grove Street side.

This house was built about 1840 and was inhabited by many families, including the Codwise family. Dr. G. W. Codwise came to Grantville with his family after retiring from his career as an American naval surgeon in 1861. Roger Babson's statistical business started here. By 1925, the Wellesley Hills Exchange had opened a market for home products here. In the handcraft department, the proprietors sold aprons, baskets, cards, linens, pewter, pictures, rugs, toys, and woolens. The food department offered bread, cakes, cookies, chicken pies, jellies, muffins, sandwiches, and salads. Luncheon and tea was served at the exchange daily and private parties were welcome to use a room in the house for functions. According to the rules for consignors, "saleable articles [were] received subject to the approval of an examining committee. The Exchange [did] not guarantee that any article [would] be sold, but act[ed] solely as an agent for the consignor."

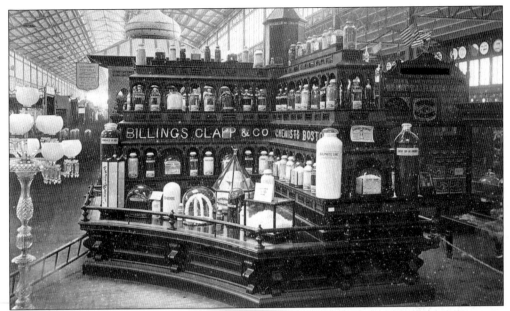

Started by Charles E. Billings and Albion R. Clapp in 1872, Billings, Clapp, and Company manufactured chemicals in the Lower Falls in the old stone building at 18 Mica Lane. Clapp later sold his share of the business in 1896 to Billings's son, Edgar, who later closed the business. Clapp was responsible for bringing gas into Wellesley Hills in 1880. The gas line extended into Wellesley Square in the 1890s.

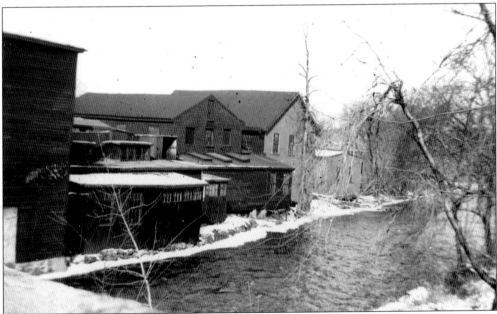

Richard T. Sullivan bought this mill site in 1874; it had opened as the Nehoiden Paper Mill in 1794. Along with John Bowen, Sullivan started R. T. Sullivan at Newton Lower Falls to extract "woolen rags and [reduce the] same to fibre." In 1898, the mill became incorporated as the R. T. Sullivan Company. The former mill site at One Washington Street later became the Wellesley offices for Congresswoman Margaret Heckler.

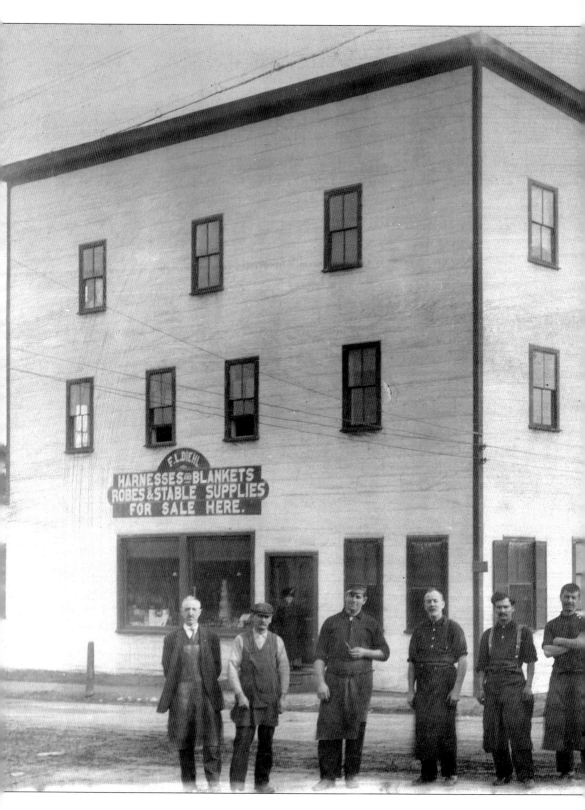

F. Diehl and Son originated when 12-year-old entrepreneur William Diehl began selling cordwood in South Natick. Four years later he bought land on Linden Street from the Hunnewells to expand his business, though the land had to be in his father's name. In a 1939 newsletter produced by F. Diehl and Son, a description of the company holdings along Linden Street included the mention of a coal yard, oil storage, grain shed, cement shed, and hay shed. Before the company started delivering oil in 1929, coal and ice drawn from a pond at the future Sprague Field were the main products. Throughout its existence, F. Diehl and Son was a family business based on loyalty. In 2000, Diehl Oil merged with James Devaney Fuel Company in Newton. Roche Brothers supermarket is currently on the site where Diehl's buildings once stood.

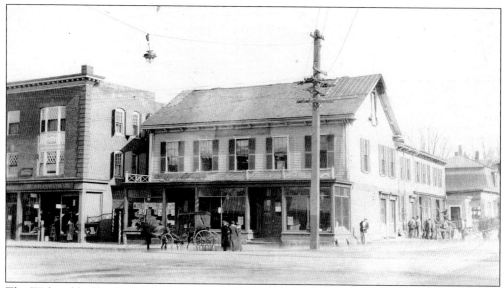

The Waban block started as a single store in Wellesley Square called Waban Hall. Built in the 1850s, it was the second store in the square. Waban Hall was expanded until it became the Waban block, later the Montague. A fire destroyed the block in 1912; this photograph shows the building after the fire. The Waban building replaced it two years later.

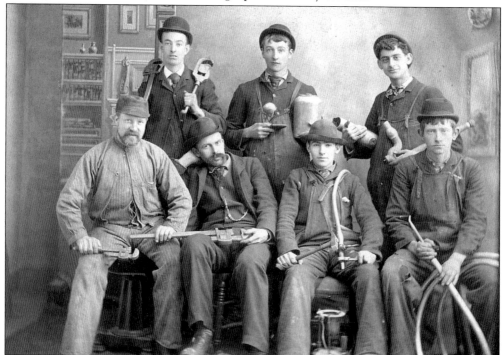

This photograph depicts Frank H. Porter, a plumber in Wellesley at the dawn of the 20th century, and his assistants. According to a July 1908 issue of the *Wellesley Townsman*, Porter headquartered his business in the Taylor block in Wellesley Square, adjacent to the old Waban block. The advertisement read, "F. H. Porter, Dealer in Hardware and Stoves—Paints, Oils, and Varnishes—Gaspiping, Tin and Sheet Iron Work—Plumbing and Heating—Telephone Connection."

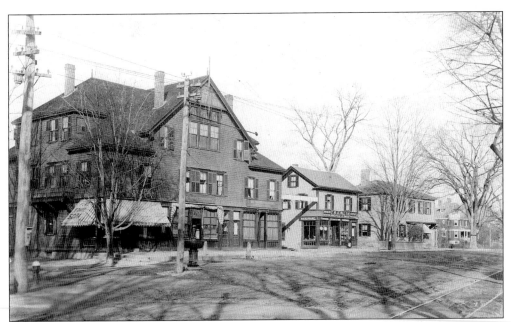

Lyman Putney came to Grantville around 1870 and lived on Oakland Street. After his career with the Boston trucking firm Whipple and Company, Putney developed real estate in Wellesley Hills during his retirement. He built a commercial block on the north side of Wellesley Hills Square that later became known as the McLeod block but was known as Putney block when this photograph was taken.

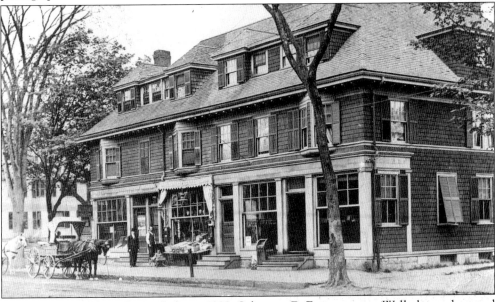

After emigrating from Gaeta, Italy, in 1898, Salvatore DeFazio came to Wellesley and opened a general store across from the Wellesley Hills railroad station in what became known as the DeFazio building. Salvatore DeFazio Jr. opened his own printing business at his home in 1929 before moving to a commercial location in the hills. Salvatore DeFazio III continues to operate the Windsor Press in the DeFazio Building. The general store became a delicatessen and closed in 1982.

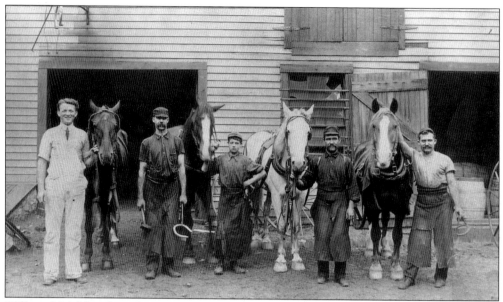

William M. McLeod was born in Framingham in 1859, but grew up in Wellesley and remained here throughout his adult life. After graduating from the public schools, he became a businessman in Boston before returning home to purchase a grocery business in Wellesley Hills Square in 1885. McLeod was active in town affairs as a member of the Maugus and Nehoiden Clubs and the Republican town committee. At the dawn of the 20th century, grocers delivered their goods to the consumers' homes. Store owners like McLeod and Salvatore DeFazio often knew their customers' names. In addition to his grocery, McLeod also operated a blacksmith shop. Wellesley Hills became a booming business center in the late 1800s with a variety of stores, from hardware to hand laundries. Shown above is the blacksmith shop located behind McLeod's grocery around 1901. Below is the interior of McLeod's shop.

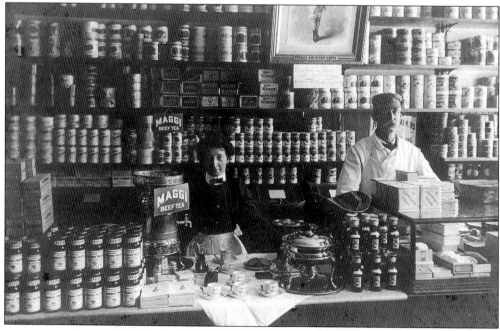

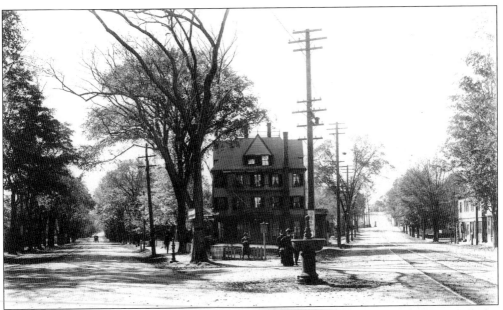

Calvin Fiske and David Smith erected the Elm Park Hotel in 1808 in what is currently Wellesley Hills. In 1811, it was known as the Needham Hotel. It later became the Grantville Temperance House in 1849. Around 1857, the building became a day and boarding school called the Elm Park Institute. Finally it transformed into a popular country resort after an 1883 renovation. On the morning of May 13, 1908, a breakfast was held at the hotel to raise funds to purchase the property to create a public park. Among the breakfast guests were students from Wellesley College, members of the board of selectmen, Chief Harry M. Kingsbury of the police, and representatives from other town departments. The lower photograph depicts people in front of the hotel that day.

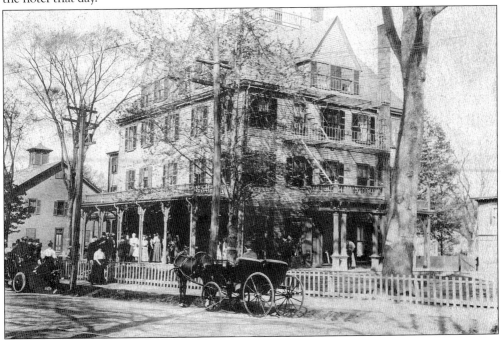

The Eaton Print Shop housed the Maugus Press, which preceded the Wellesley Press as Wellesley's first printing establishment. Charles Marvin Eaton had established the Maugus Press in the 1880s. The Maugus Printing Company was incorporated after Eaton's death in 1903. This building was constructed in 1900 at the southwest corner of Forest Street and Washington Street. A year after the press's incorporation, the building was moved to the Partridge block in Wellesley Square. In 1929, the stock of the Wellesley Press was purchased by George W. Adams, who was the editor and owner of the *Wellesley Townsman*. The *Wellesley Townsman* continues to be the local newspaper.

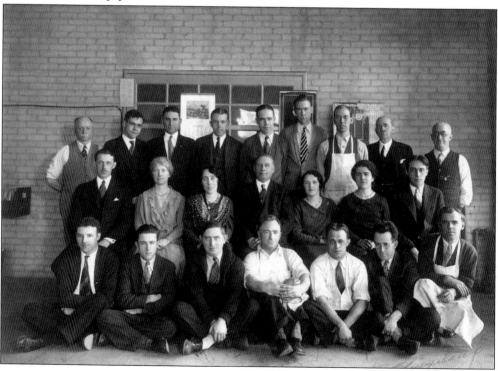

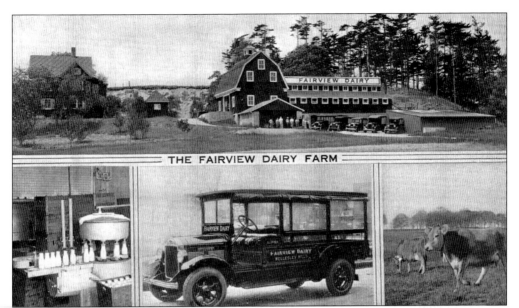

THE FAIRVIEW DAIRY FARM

According to a newspaper account from September 18, 1930, "Youngsters, and their folks, too, have come to appreciate the fine dairy products of Wellesley's own Fairview Dairy through the years, over 100 years to be more specific . . . Local homes on the Fairview route are assured of reliable deliveries and courteous service as well as the fresh, pure products the trucks carry." The dairy was located at the corner of Cedar and Worcester Streets and has since become the Deerfield Senior Center.

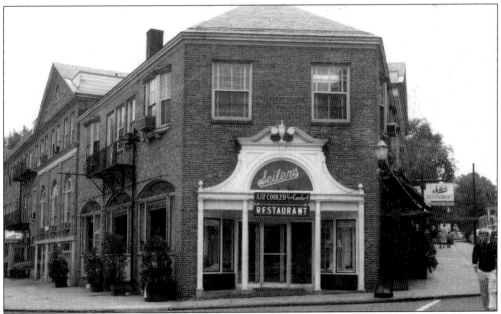

Before Anderson's Jewelers occupied the store at the corner of Grove and Washington Streets, Seiler's restaurant fed visitors in the square. In the 1940s, the owners advertised, "Here we gather in the old English Room for Breakfast, Luncheon and Dinner. The Hearth Room, so delightful for Birthday parties. From the Soda Fountain delicious creations. Ice cream, Pastries . . . birthday cakes, candies and favors sent to your home."

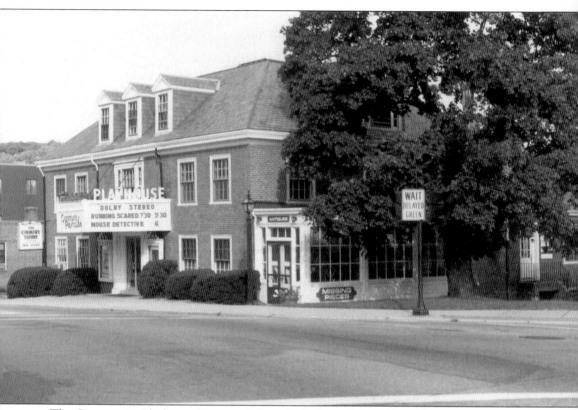

The Community Playhouse began its life as the Babson Community Theater around 1920. In addition to the theater, it had a cafeteria that served three meals per day that was open to the public as well as students and employees of Babson Institute. On the Forest Street side of the theater, the first floor had a tea room and a reading room. When the Babson Institute moved to Wellesley Avenue and Forest Street, Adolph Bendslev bought the playhouse. It remained open, showing second-run films, until February 28, 1987. The theater had had the first Dolby Surround Sound system in the Boston area. The theater building continues to exist in Wellesley Hills today. When the FIC Development Corporation bought the playhouse, it decided to keep the building and adapt it to fit the needs of the next tenants rather than demolish a beloved town landmark.

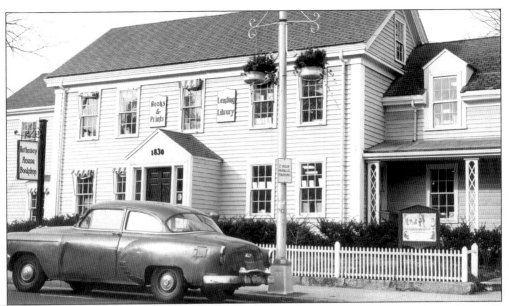

Founded by two Wellesley College professors, the Hathaway House Bookshop opened in 1925 "to increase the educational opportunities of Wellesley College and the town of Wellesley." The cellar of the house served as the college bookstore from 1927 to 1973. The bookshop closed August 1, 1979, because it could not keep up with discount stores. It was remembered for its knowledgeable staff and friendly service. Stuart Swan Furniture currently occupies this building.

William Filene opened his store in downtown Boston in 1890, selling women's apparel and other goods. Alfred Fraser, a Wellesley florist and prominent Central Street businessman, was largely responsible for bringing the store to Wellesley in 1924. A 1944 advertisement in the *Wellesley Townsman* advertised Filene's as "a modern family shop" that satisfied all ages. May department stores bought the Filene's chain in 1988 and the Wellesley store closed in 1992.

Icehouses were essential to the pre-refrigeration economy. Icemen in Wellesley and other New England towns cut blocks of ice to keep food from spoiling in households all over the United States. The ice was ready to be cut when the ponds were covered with ice two feet or more thick. Icemen packed sawdust between the cracks of the ice blocks and between the ice and the wall of the icehouse. At Morse's Pond (above), the Boston Ice Company harvested ice with horse-drawn plows. It was chiseled into two-foot blocks and shipped by rail. High school boys and hired men harvested the ice at the Metropolitan Ice Company on Longfellow Pond (below). People who wanted ice placed an ice card in their front windows indicating the block weight and size chunk they wanted as well as where to deliver the ice.

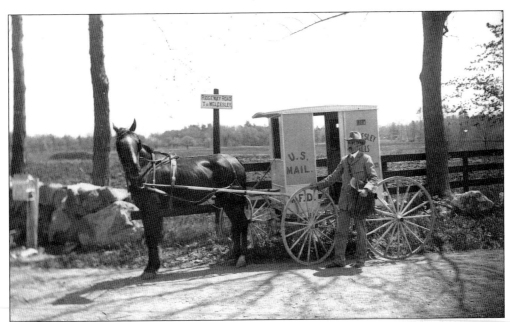

In the 19th and early-20th centuries, the local post office operated out of homes, taverns, and country stores. West Needham's first postmaster was Charles Noyes, who took the post on March 4, 1830. Mail arrived once every two days by the Uxbridge stagecoach. The stagecoach driver always had news and gossip to share, which made him a popular figure. The post office became the Wellesley Post Office in 1862 to honor H. H. Hunnewell. The post office often changed location with each new postmaster, from Flagg's Tavern to Blanchard's, to the Waban block, to the Shattuck, and to its current location at Grove Street and Railroad Avenue. Shown in the top photograph is Mr. Ballou, Wellesley's mailman around 1901, as he headed into Wellesley from Weston. The photograph below shows Wellesley's postmen after World War II.

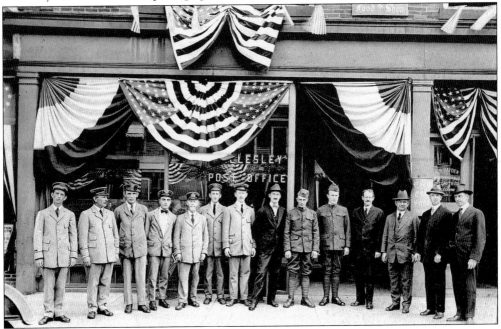

Over the course of the 19th century, Wellesley became known for its healthful air and hospitality. Built in 1860, the Wellesley Inn on the Square was originally the summer home of Henry Fowle Durant, founder of Wellesley College. By the dawn of the 20th century, the inn had become a popular spot for Wellesley College girls. In 2004, W. B. Will Holdings, LLC of Florida purchased the inn. The firm planned to redevelop the property with the idea that it could become a mixed-use building for both retail and residential space. Because the Wellesley Inn did not have the same kind of protection that buildings in the historic district have, the firm was free to alter the building as it saw fit. The inn ceased operations in June 2005 and has since been demolished.

BIBLIOGRAPHY

Bradford, Gamaliel. *Early Days in Wellesley: Being Casual Recollections of Boyhood and Later Years, 1867 to 1881*. Wellesley, MA: Wellesley National Bank, 1929.

Bradford, Helen Ford. *History of the Wellesley Hills Woman's Club*. Natick, MA: Suburban Press, 1928.

Converse, Florence. *The Story of Wellesley*. Boston: Little, Brown and Company, 1915.

DeFazio, Salvatore III, Nancy Wiswall Erne, et al. eds. *The Wellesley Post Card Album*. Wellesley, MA: The Wellesley Historical Society, 1999.

Fielden, Ruth Smith. *History of the Wellesley Free Library*. Wellesley, MA, 1983.

Fiske, Joseph E. *History of the Town of Wellesley Massachusetts*, edited by Ellen Ware Fiske. Boston: The Pilgrim Press, 1917.

Glasscock, Jean, ed. *Wellesley College 1875-1975: A Century of Women*. Wellesley, MA: Wellesley College, 1975.

Hinchliffe, Elizabeth M. *Five Pounds Currency, Three Pounds Corn: Wellesley's Centennial Story*. Wellesley, MA: The Town of Wellesley, 1981.

Post, Winifred Lowry. *"Purpose and Personality": The Story of Dana Hall*. Wellesley, MA: Dana Hall School, 1978.

Teller, Barbara. "Historical Society is Housed in History." *A Day in the Life of Wellesley: A Special Supplement to the Wellesley Townsman*. Wellesley, MA: The *Wellesley Townsman*, 1989: 5-6.

Urann, Margaret S. *Four Tours of Historic Wellesley*. Wellesley, MA: The Wellesley Historical Society, 1968.

ACROSS AMERICA, PEOPLE ARE DISCOVERING SOMETHING WONDERFUL. THEIR HERITAGE.

Arcadia Publishing is the leading local history publisher in the United States. With more than 3,000 titles in print and hundreds of new titles released every year, Arcadia has extensive specialized experience chronicling the history of communities and celebrating America's hidden stories, bringing to life the people, places, and events from the past. To discover the history of other communities across the nation, please visit:

www.arcadiapublishing.com

Customized search tools allow you to find regional history books about the town where you grew up, the cities where your friends and family live, the town where your parents met, or even that retirement spot you've been dreaming about.